Fantastical Coloring Book

Volume Four

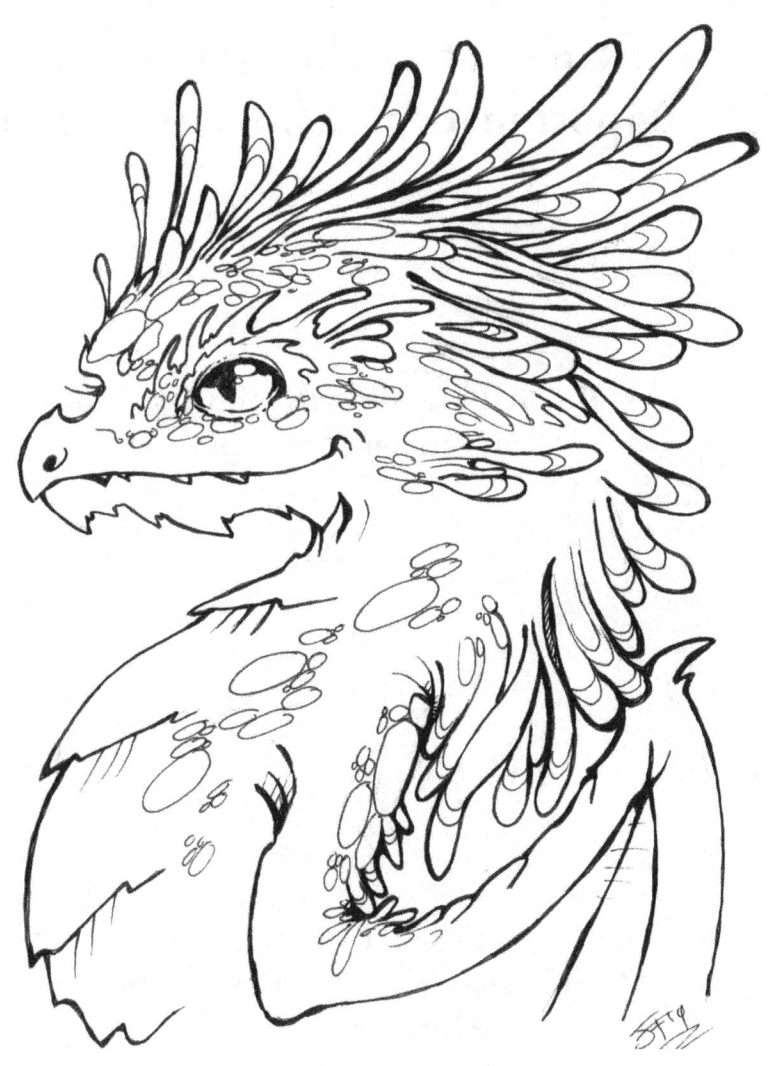

Illustrated by Jessica Cathryn Feinberg

With special thanks to:

All the fans, friends, Patreon Subscribers, and Kickstarter backers whose support made this book possible!

HELP SUPPORT THE NEXT BOOK
at Patreon.Artlair.com

FIRST EDITION
Copyright © 2019 Jessica C. Feinberg
All rights reserved.
ISBN: 9781099604416

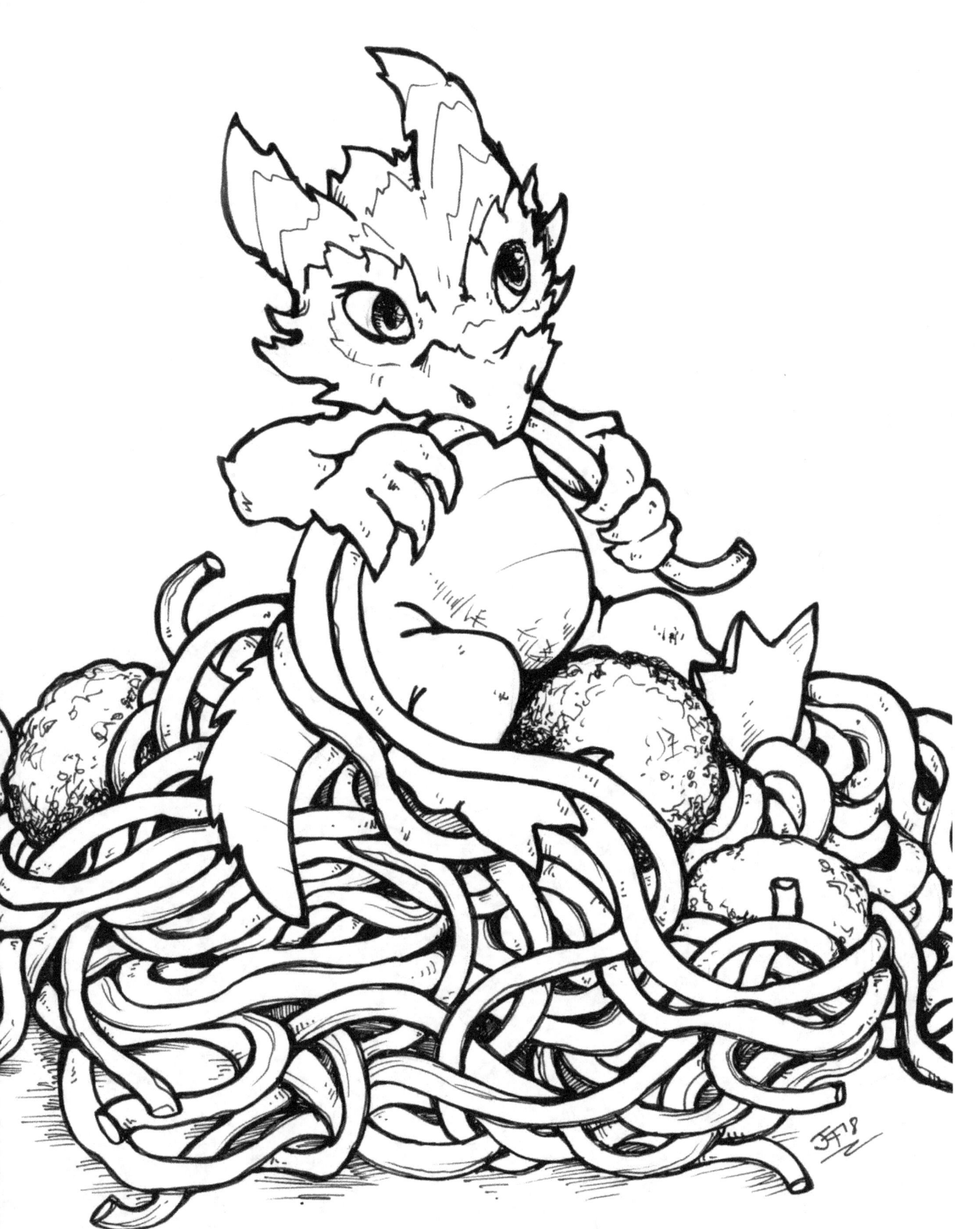

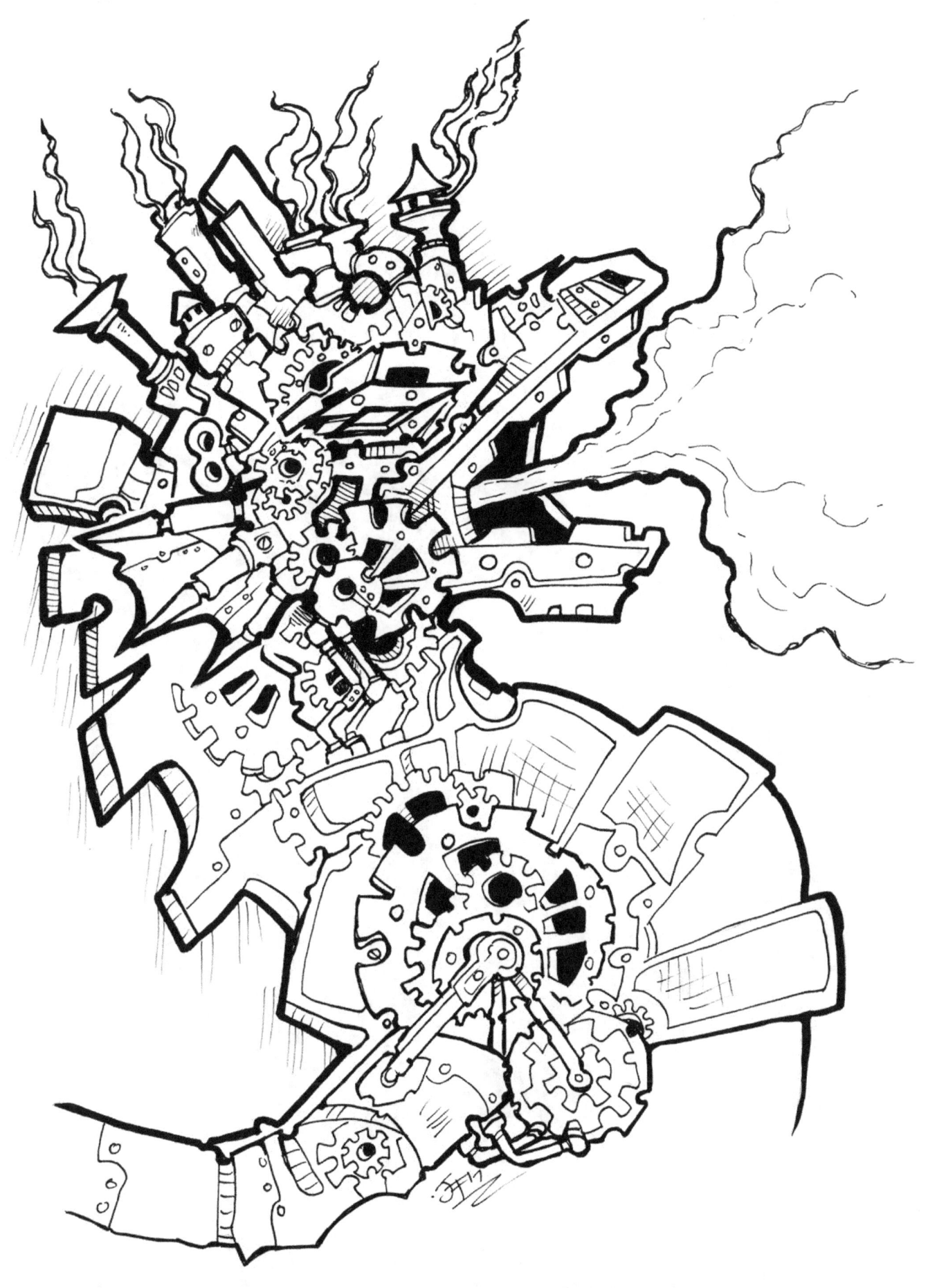

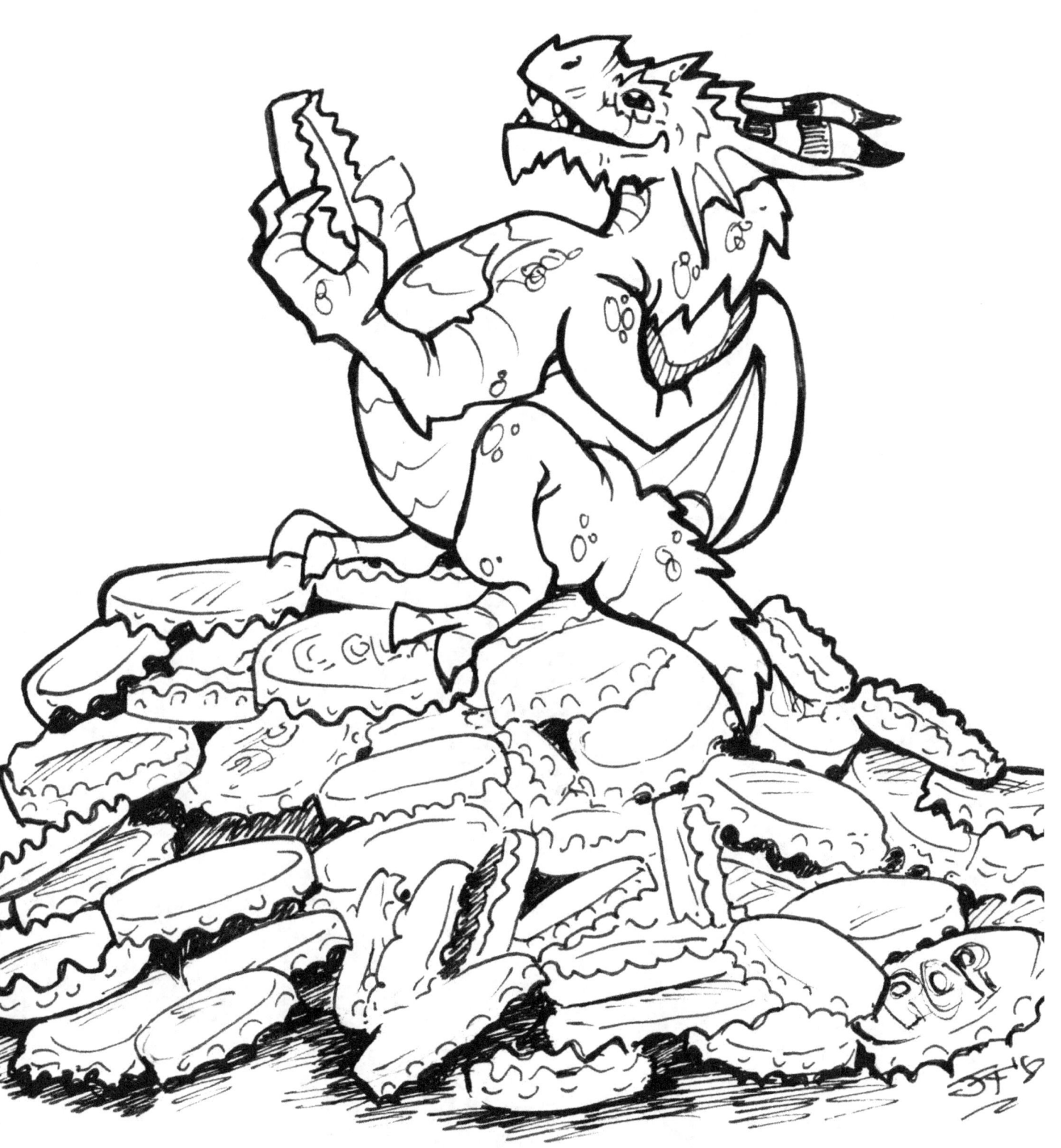

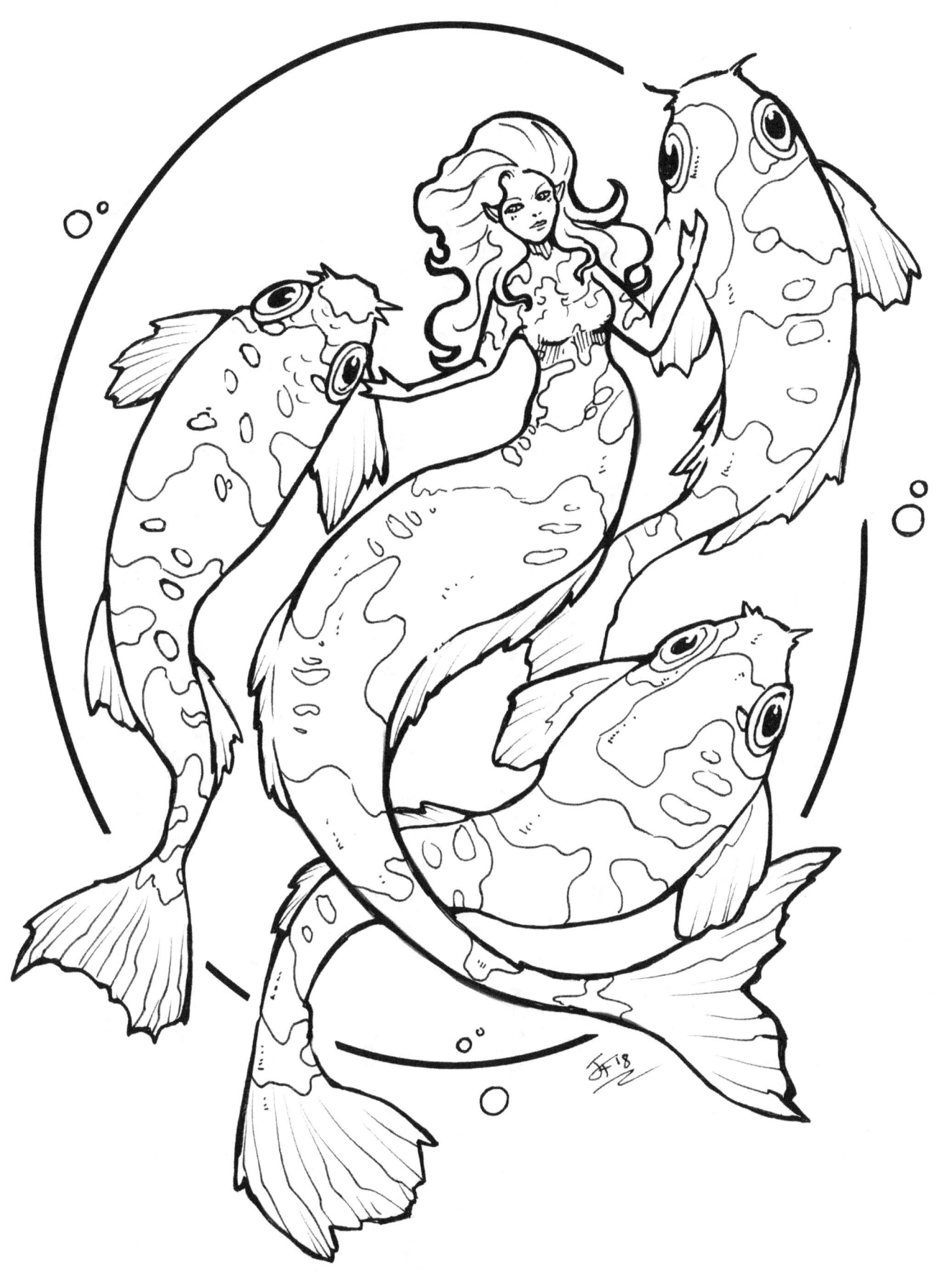

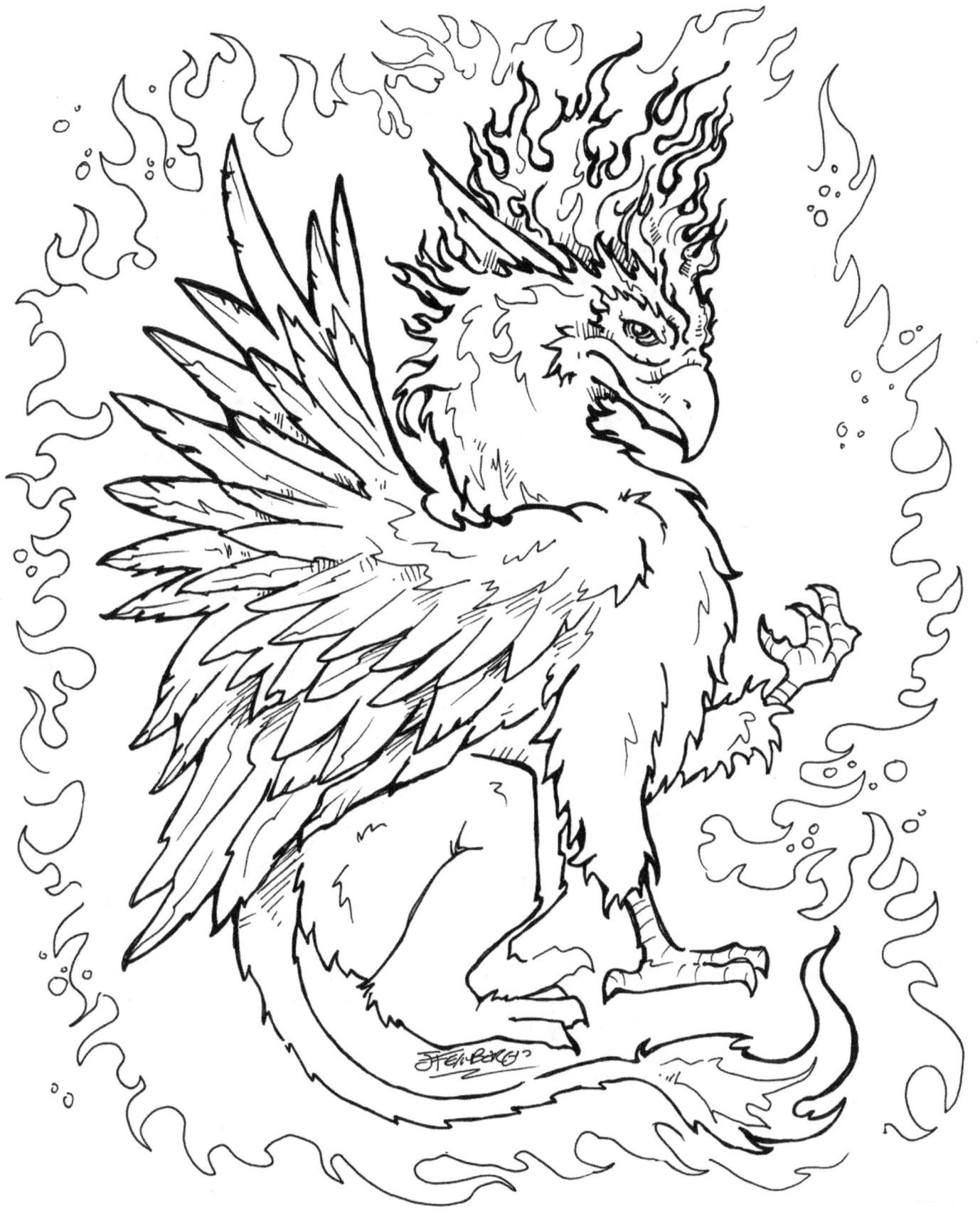

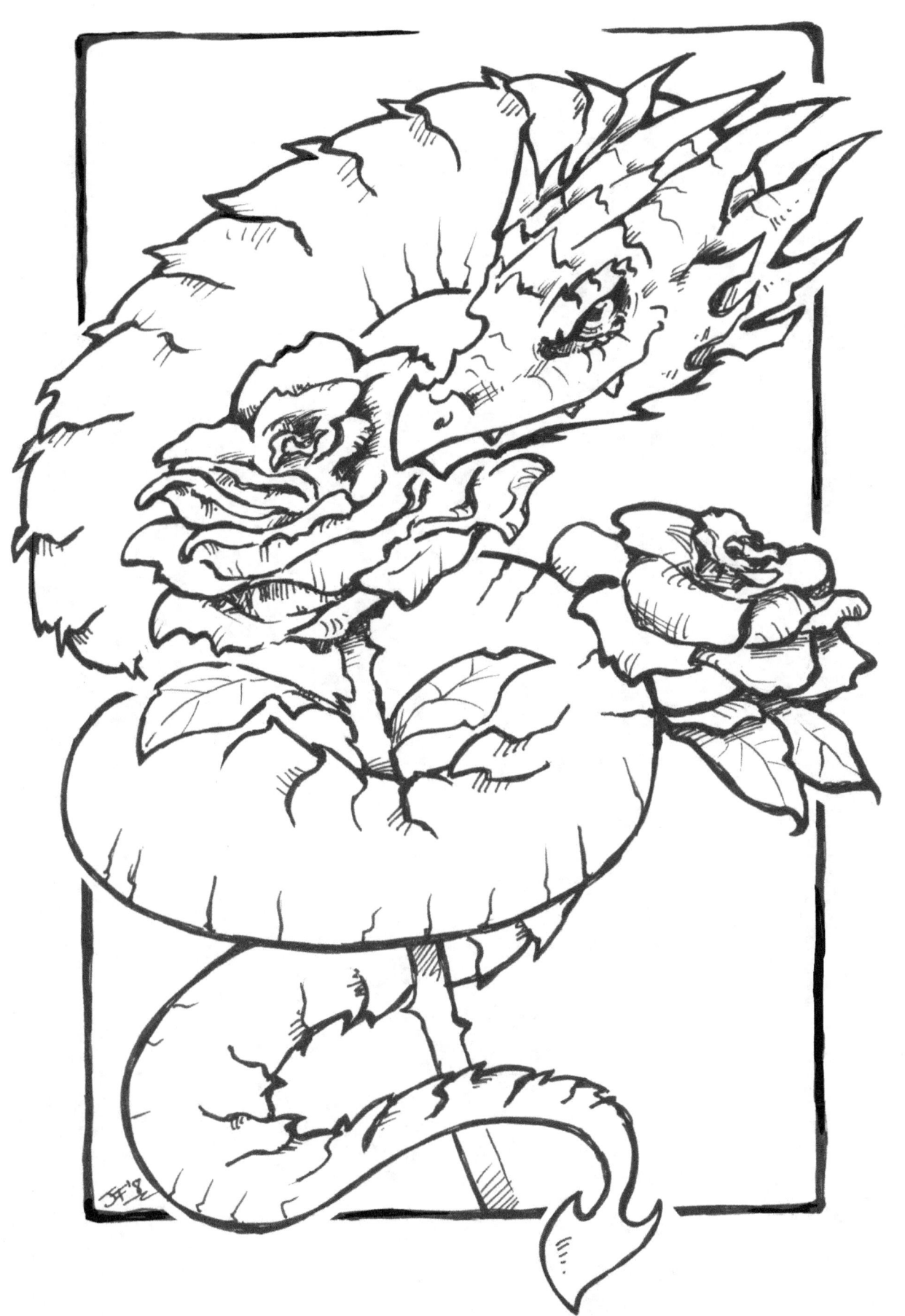

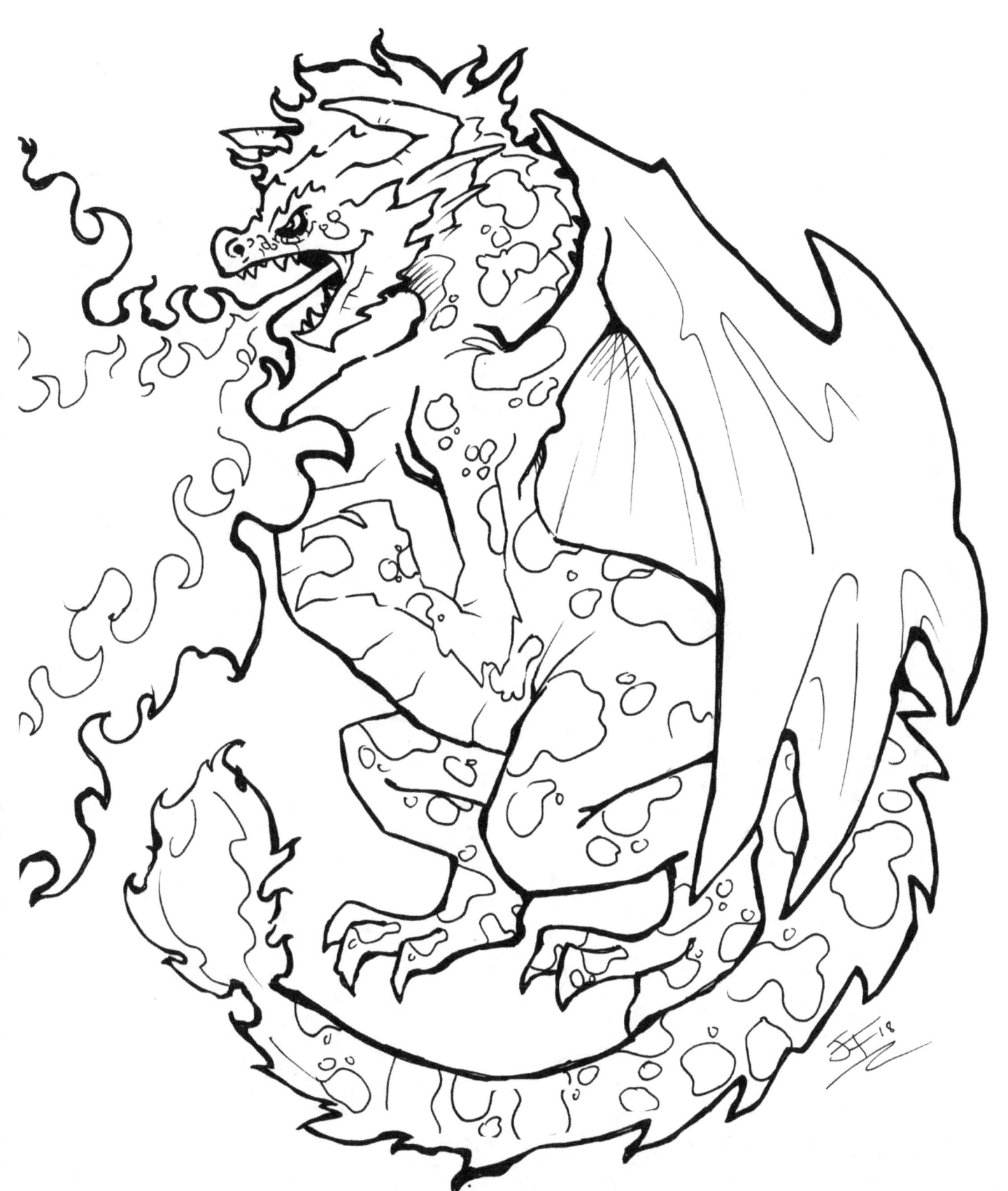

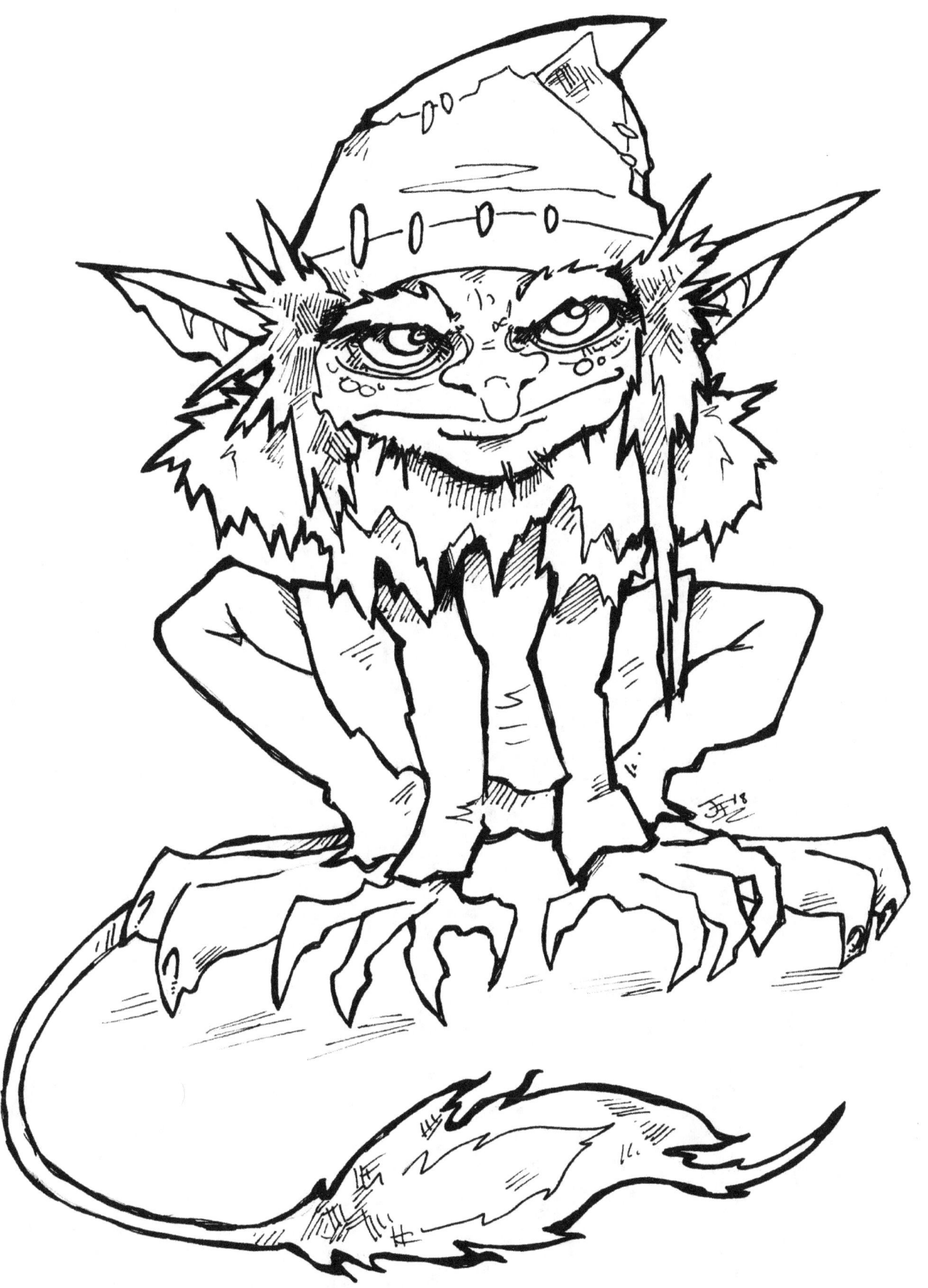

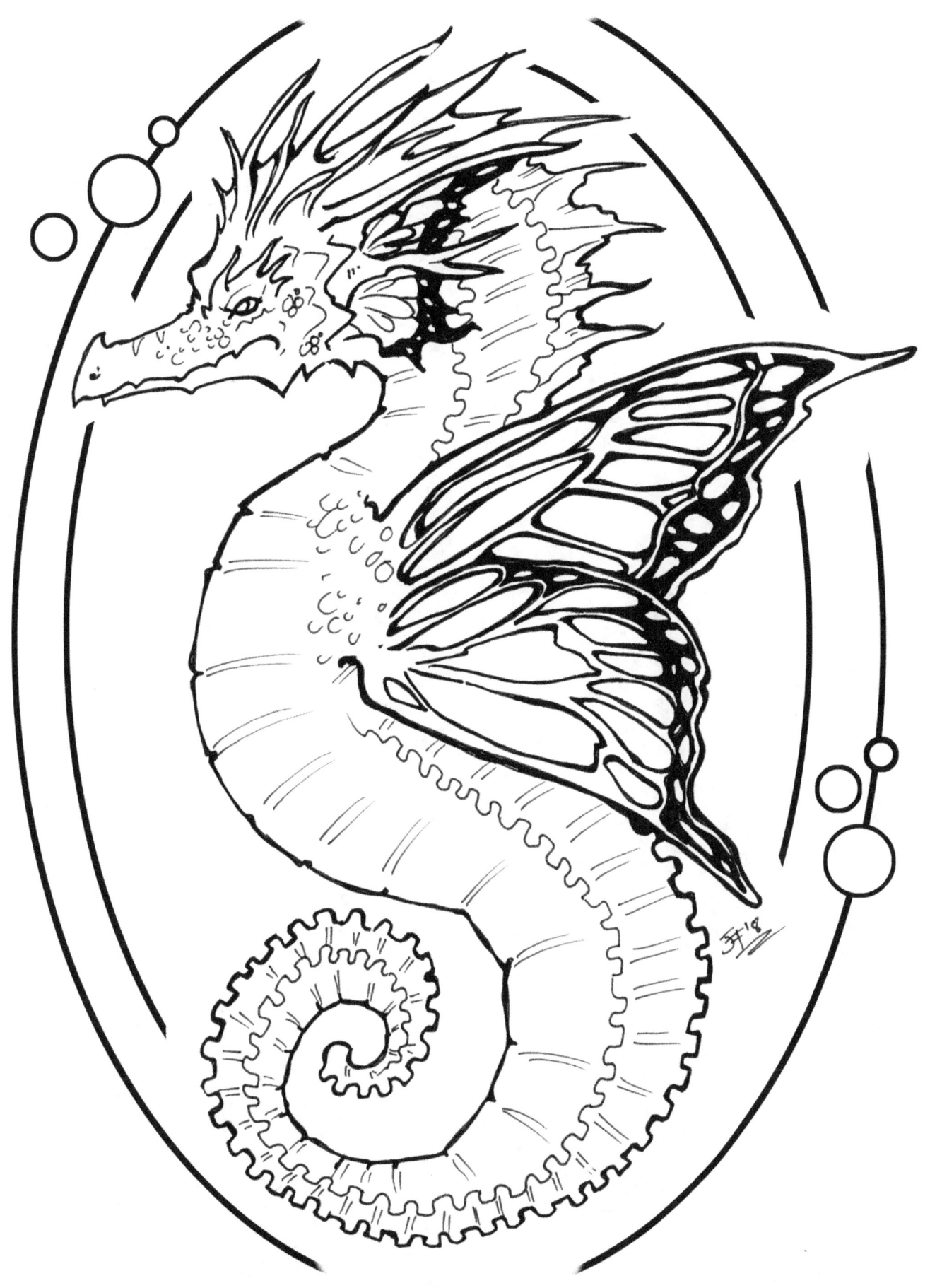

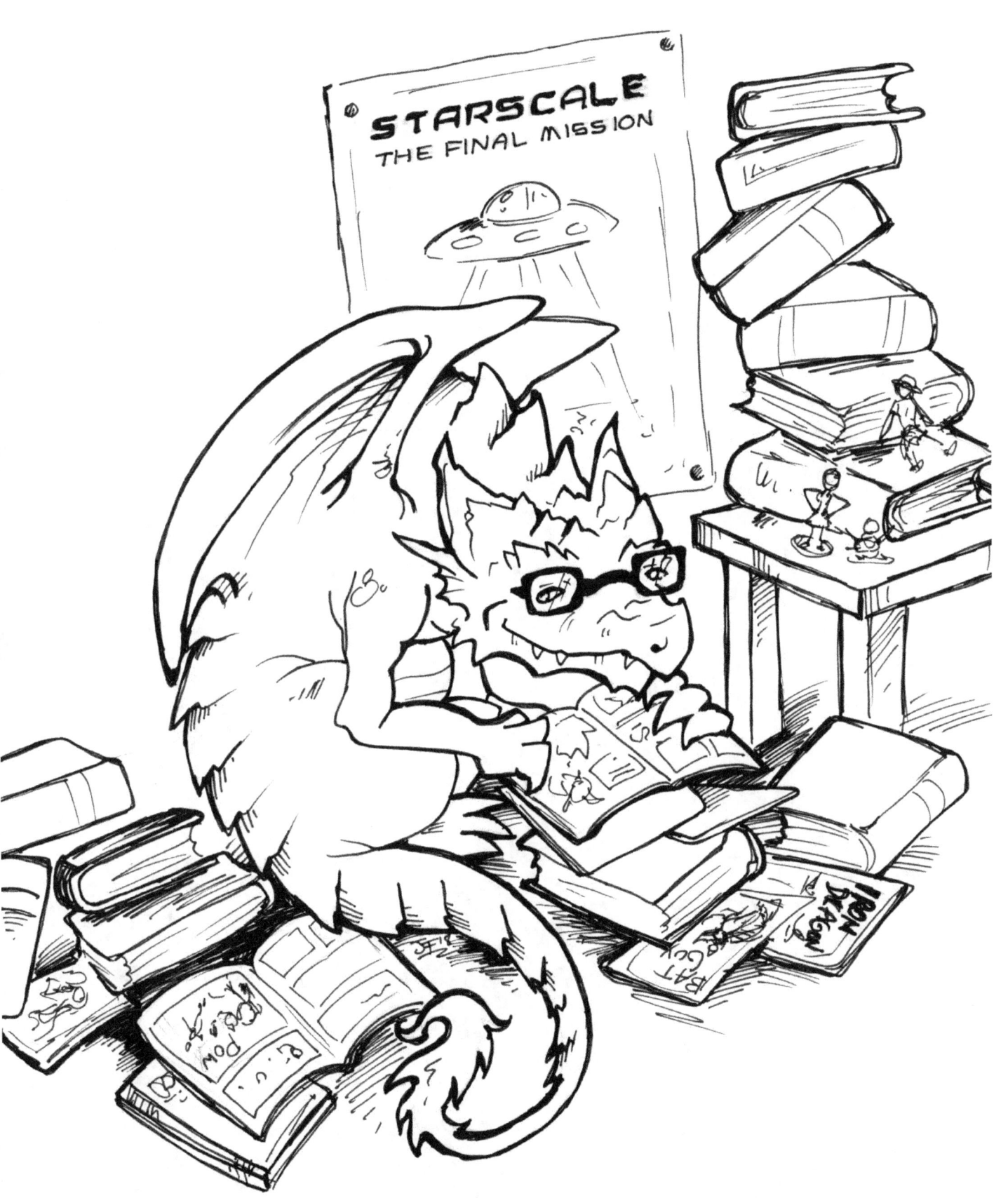

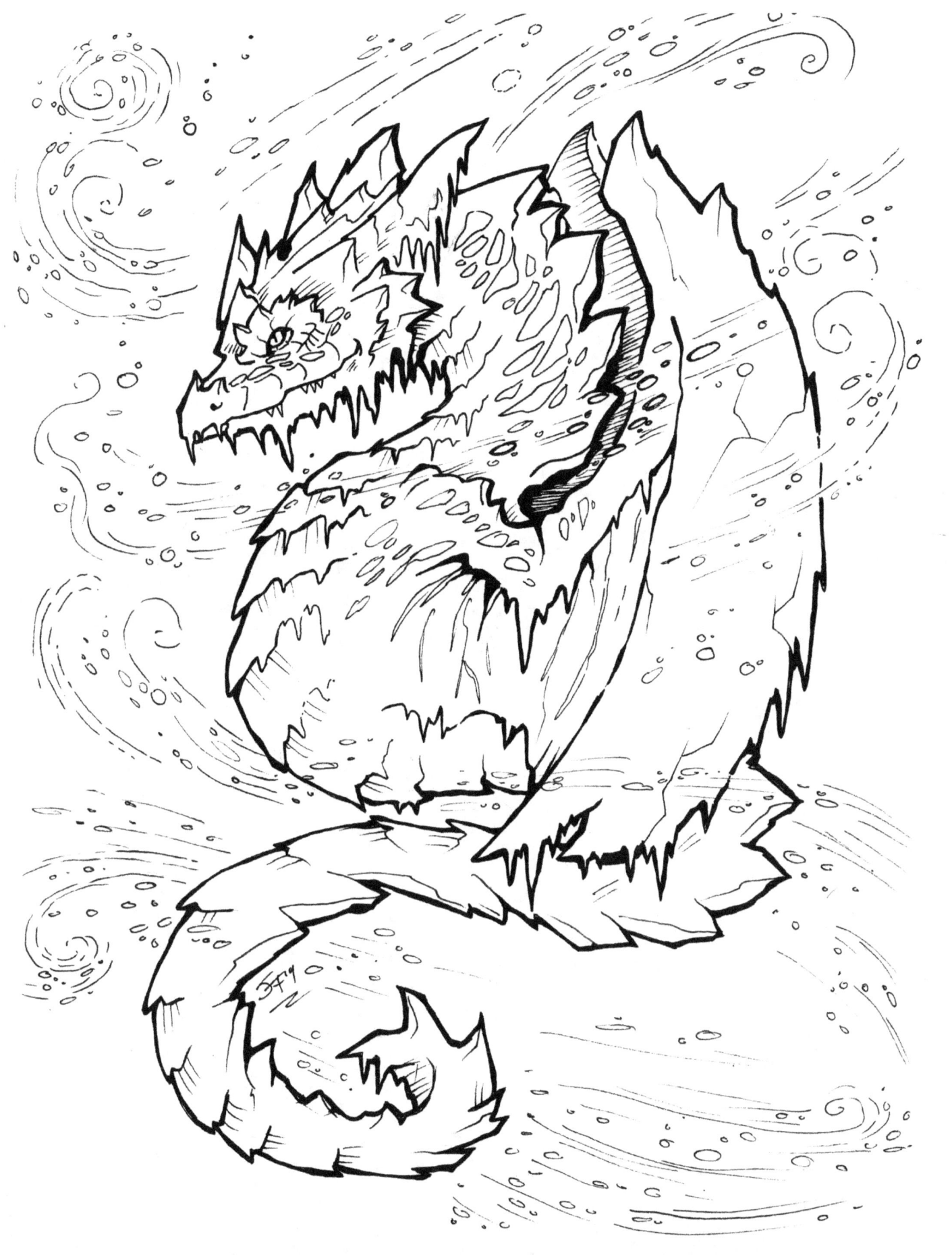

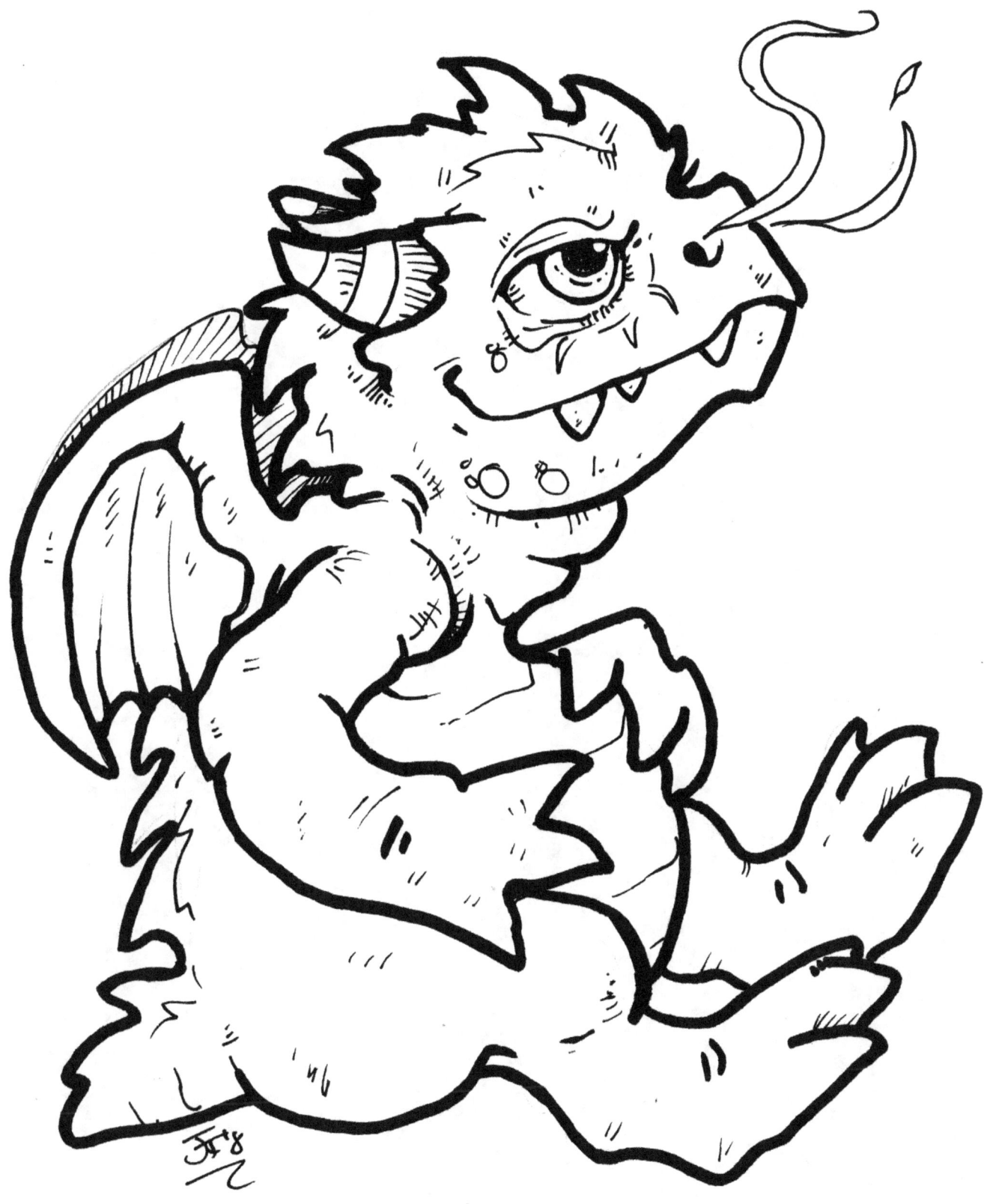

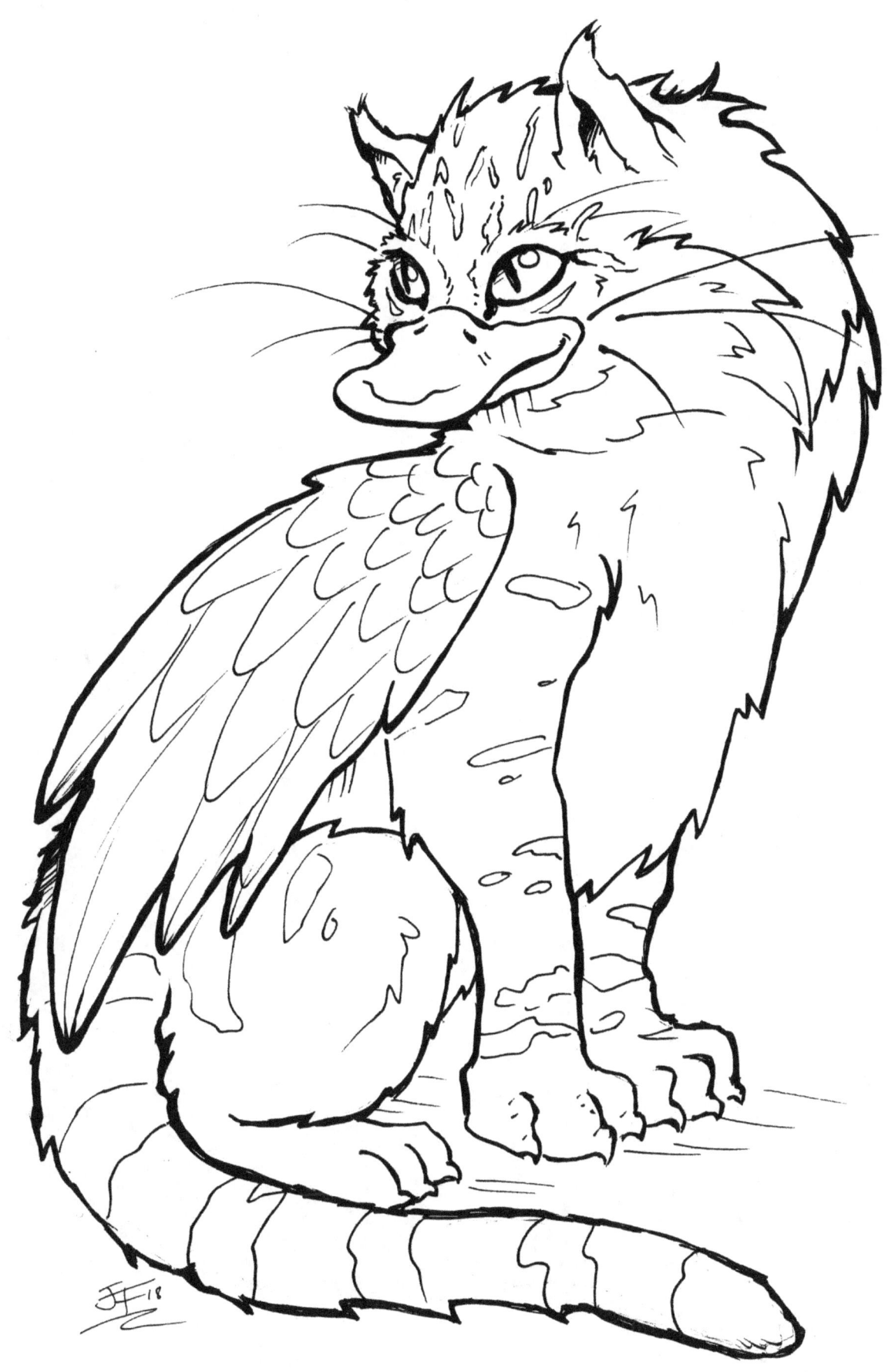

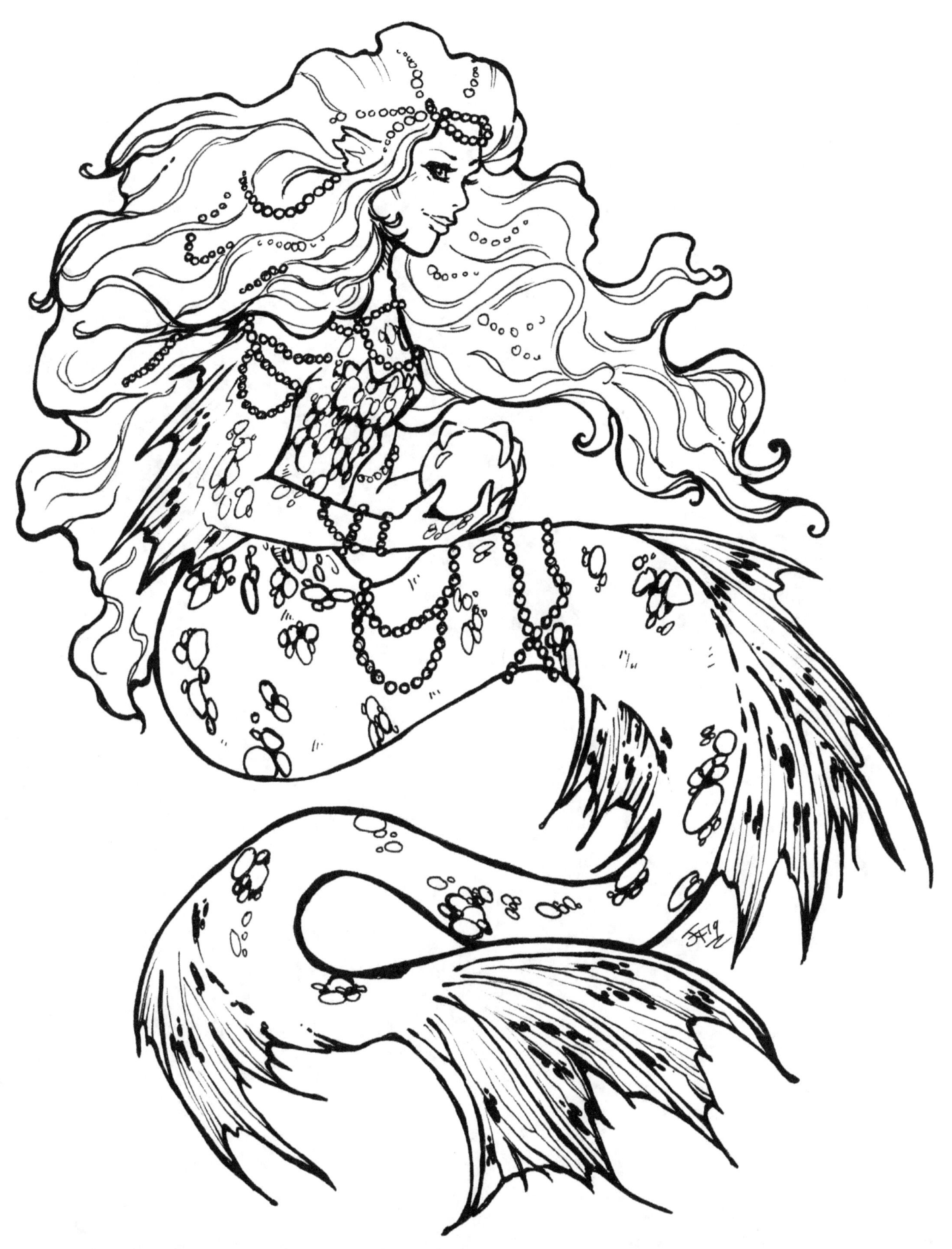

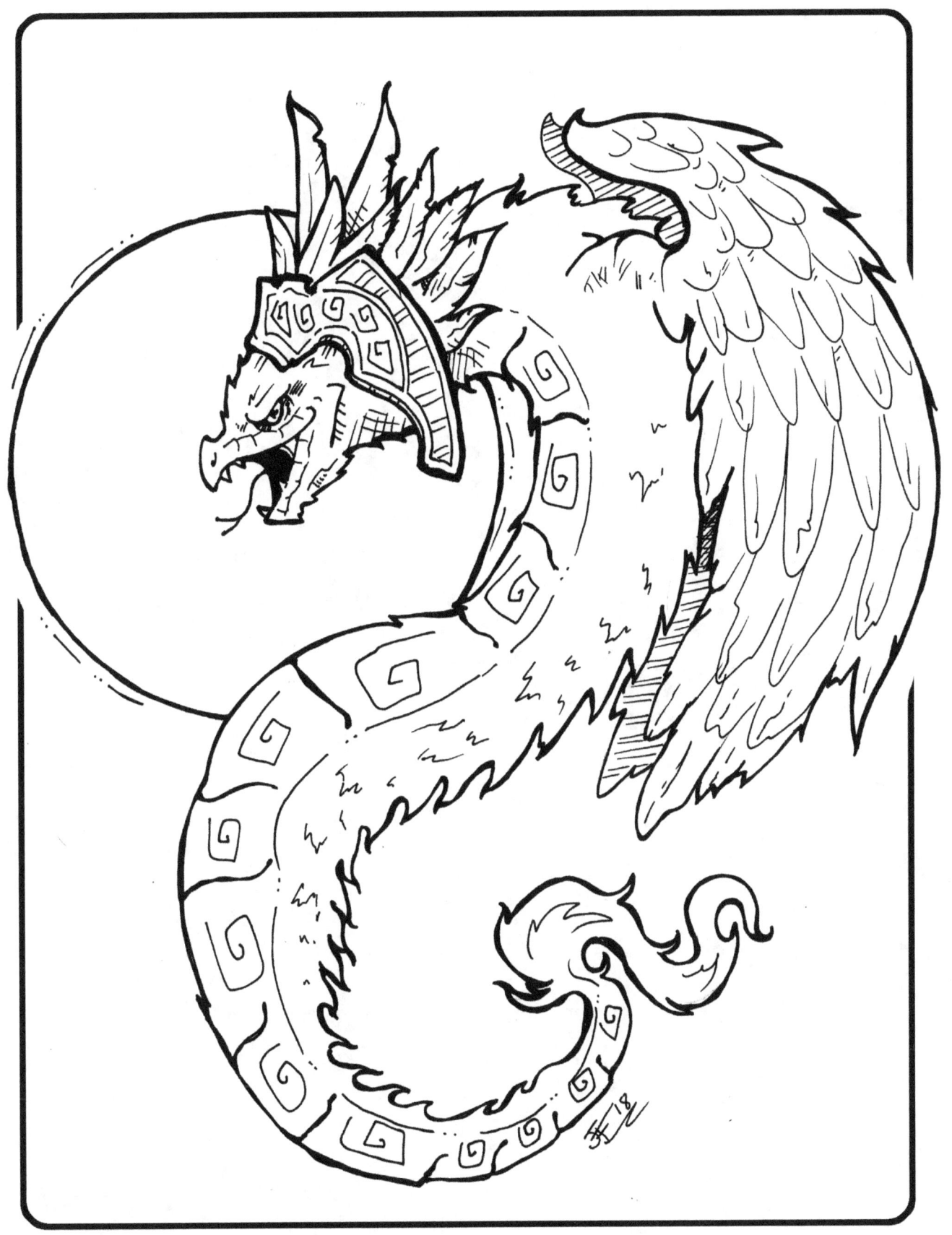

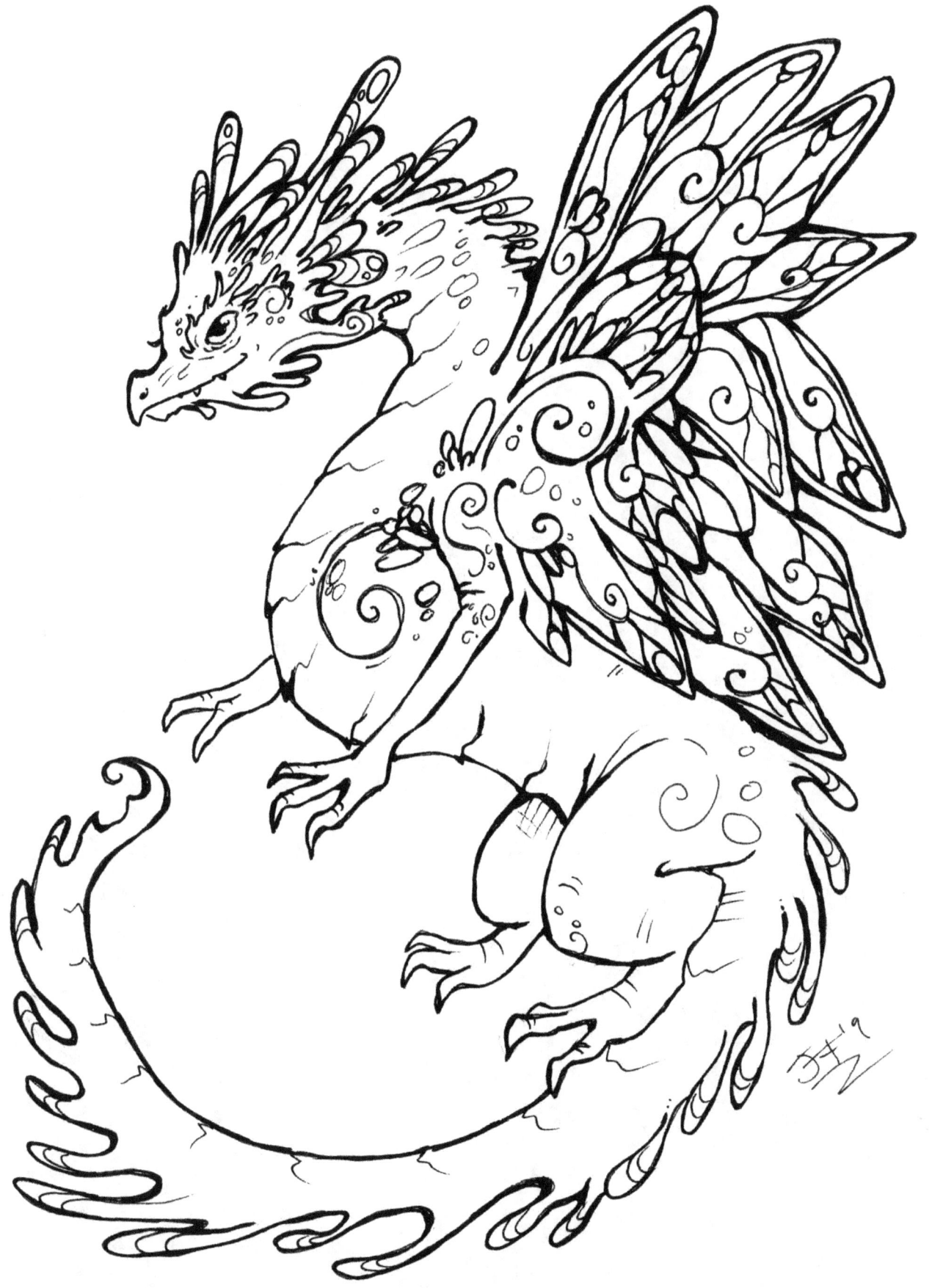

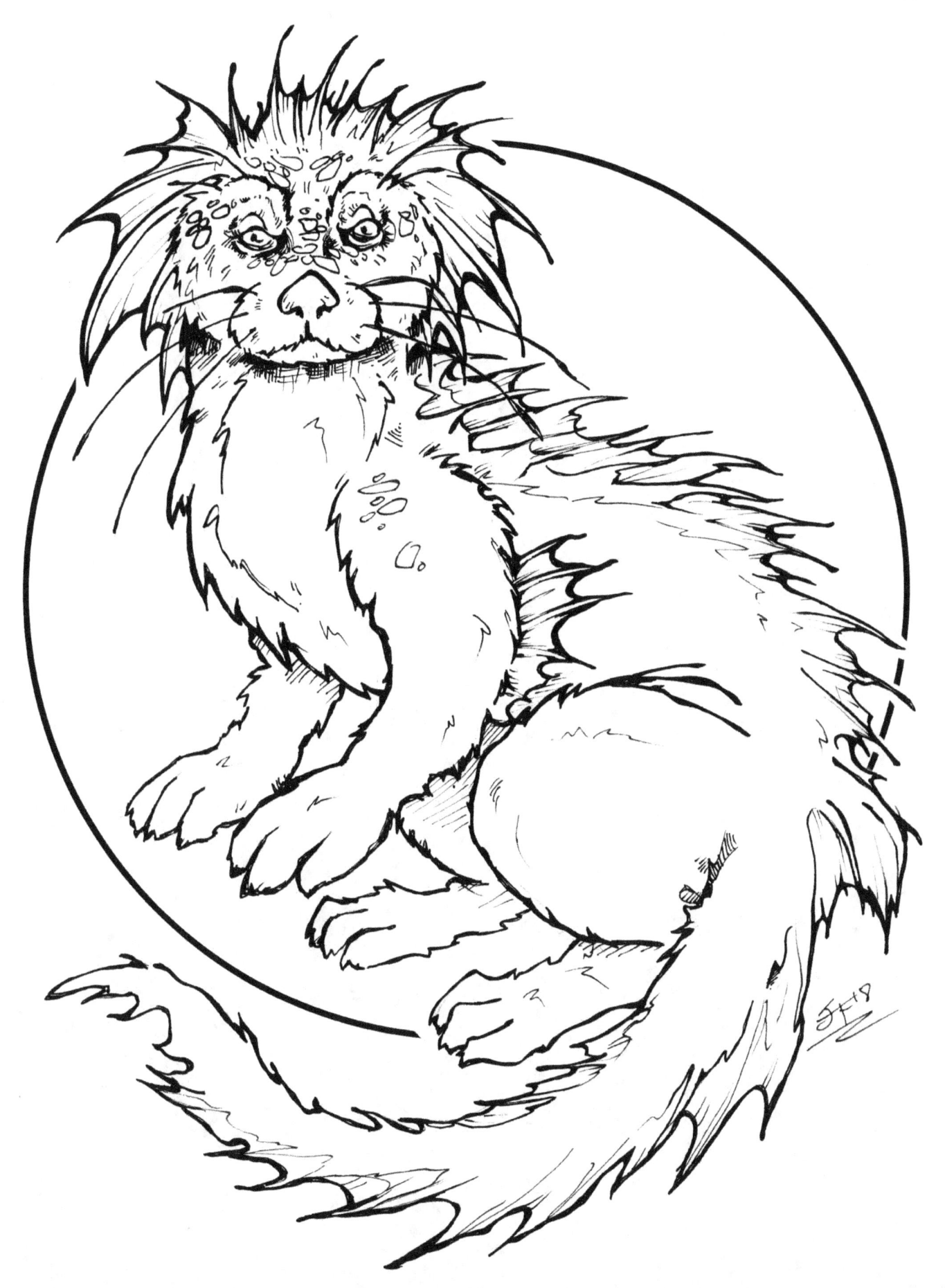

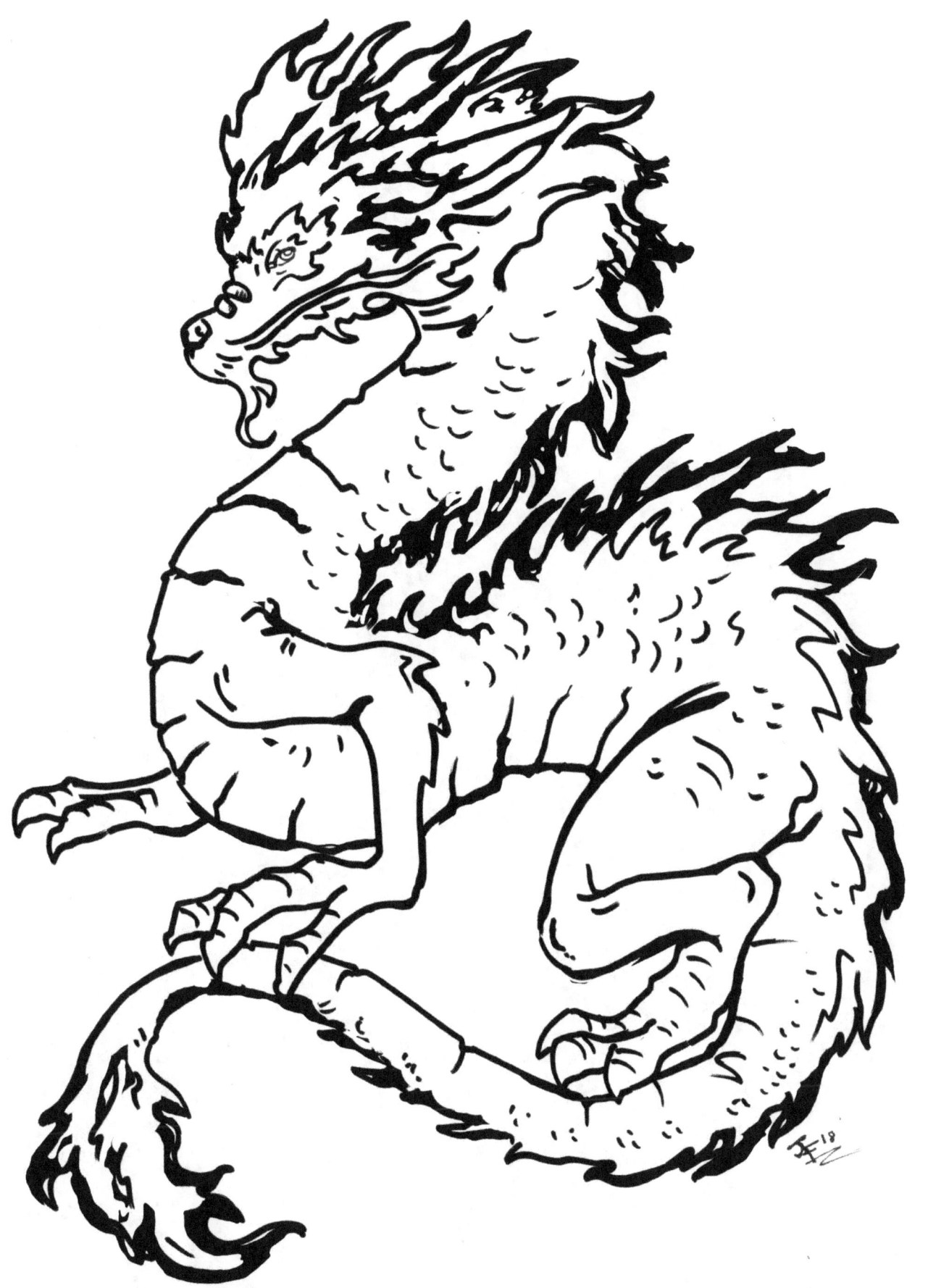

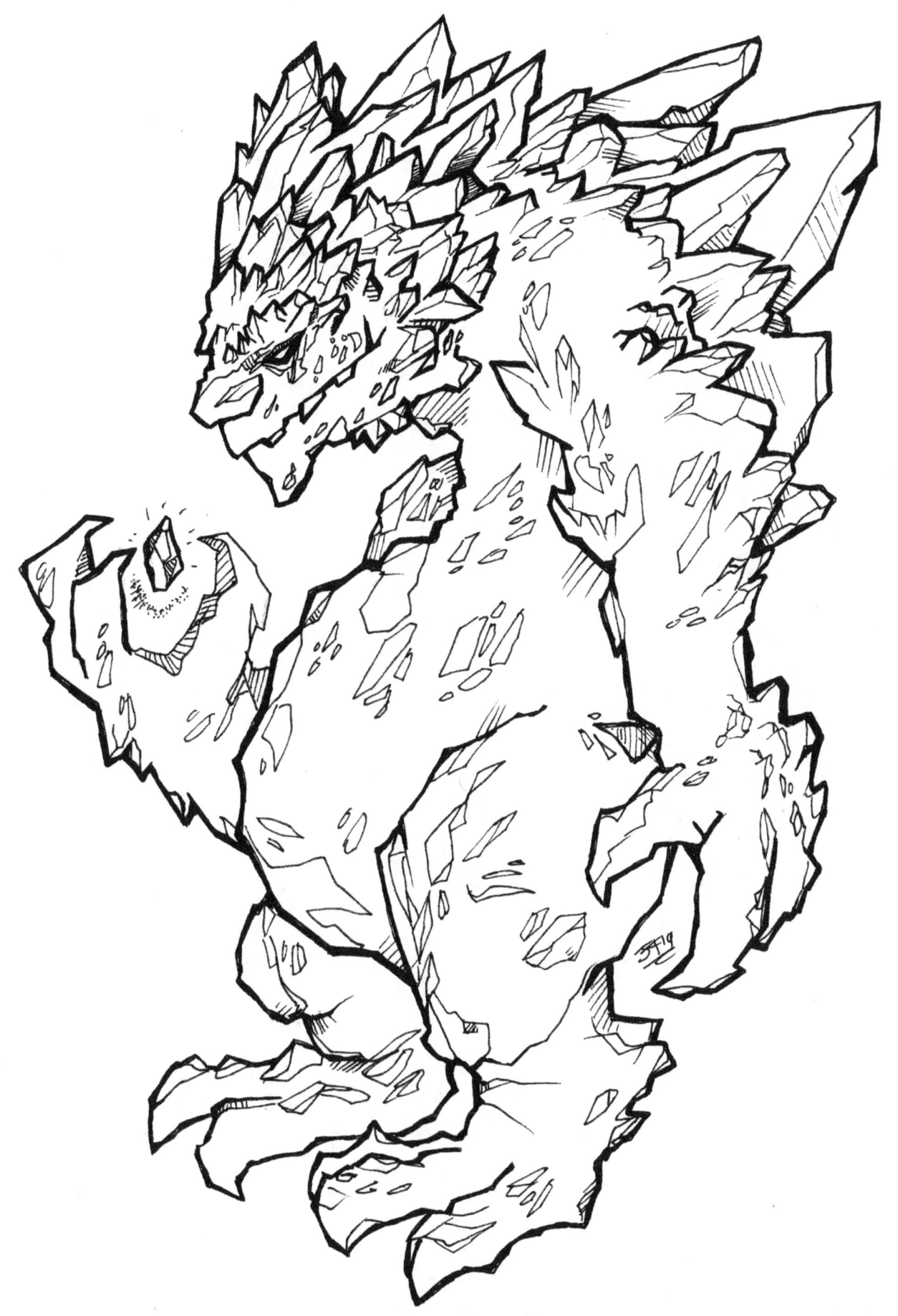

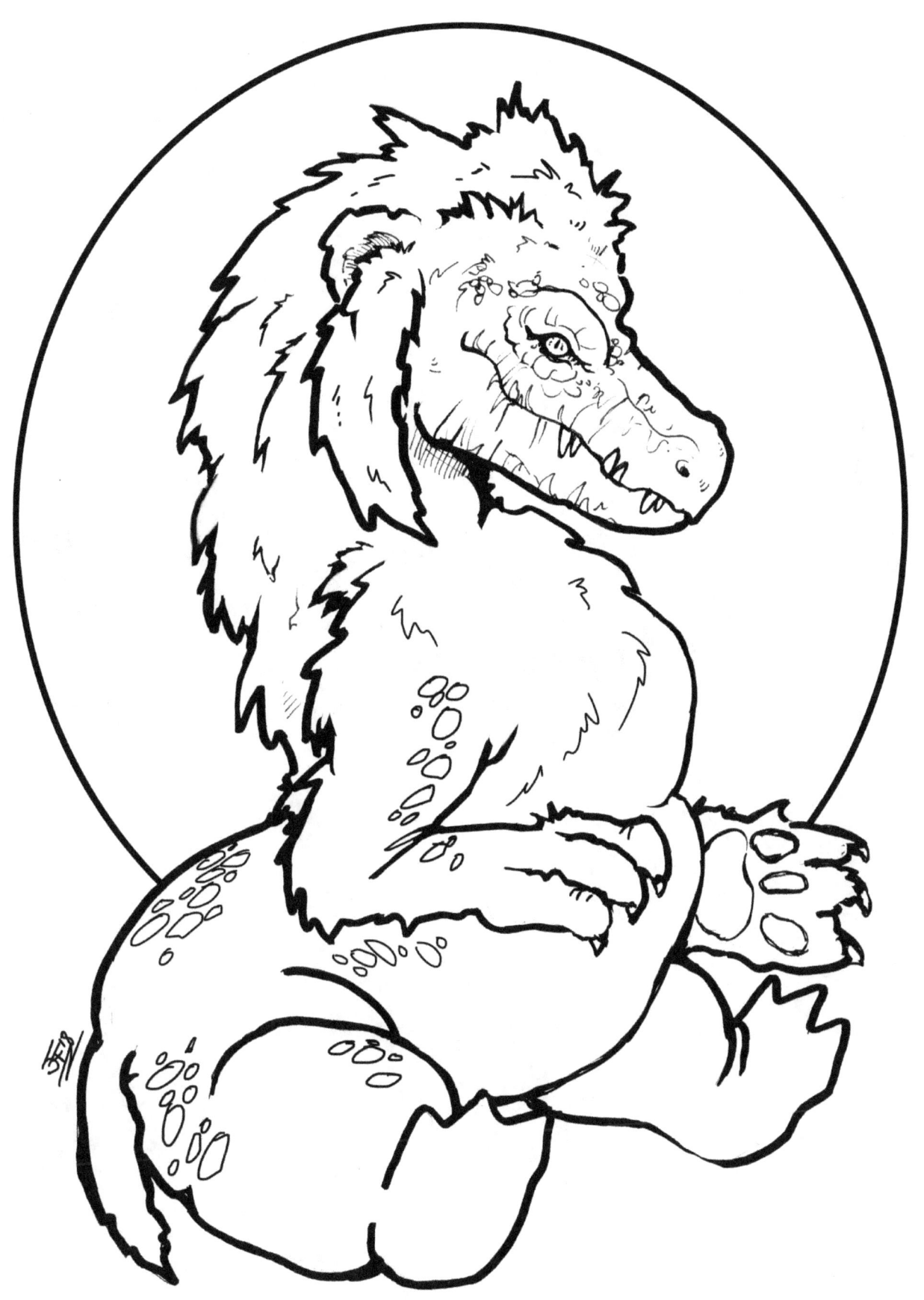

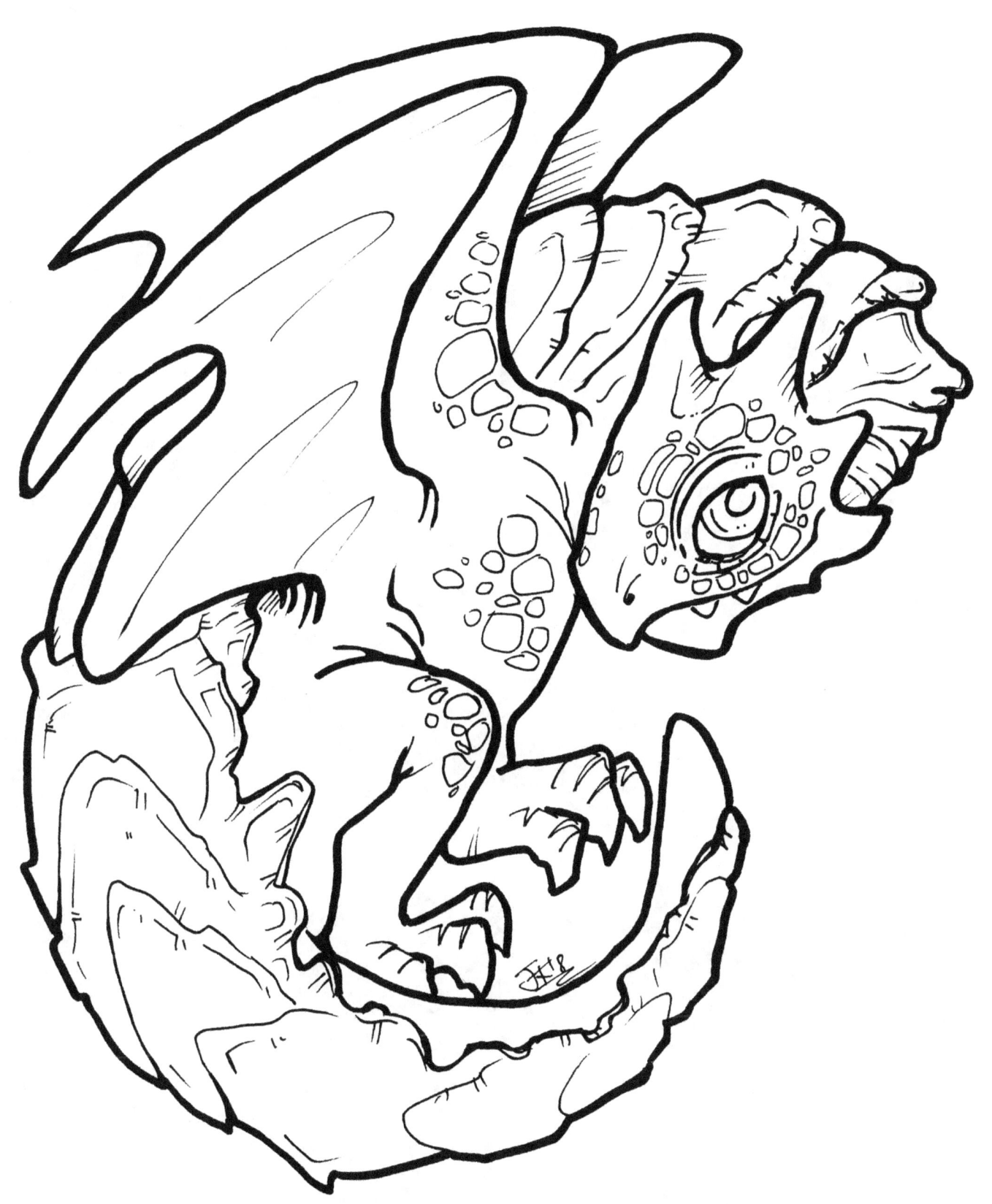

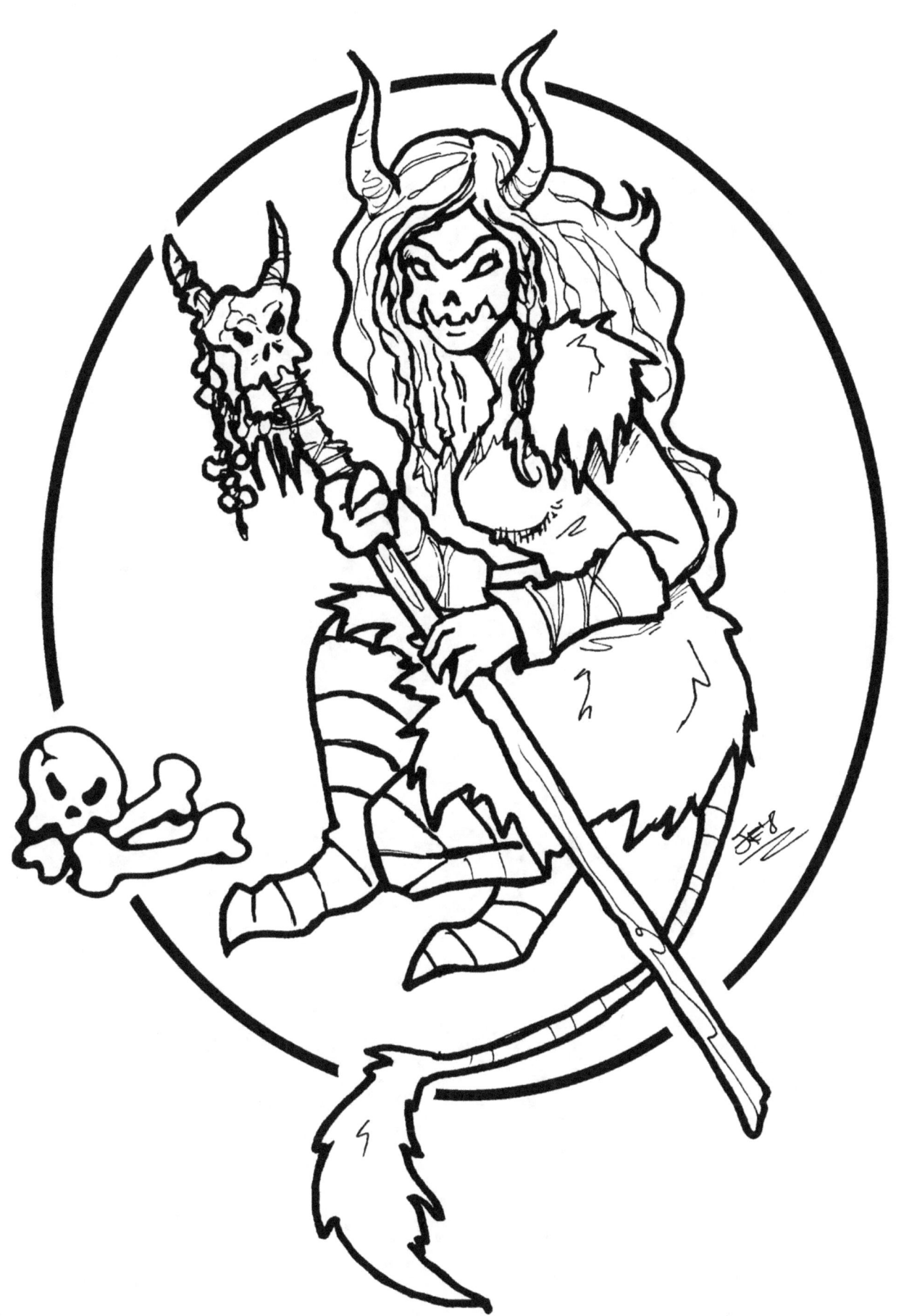

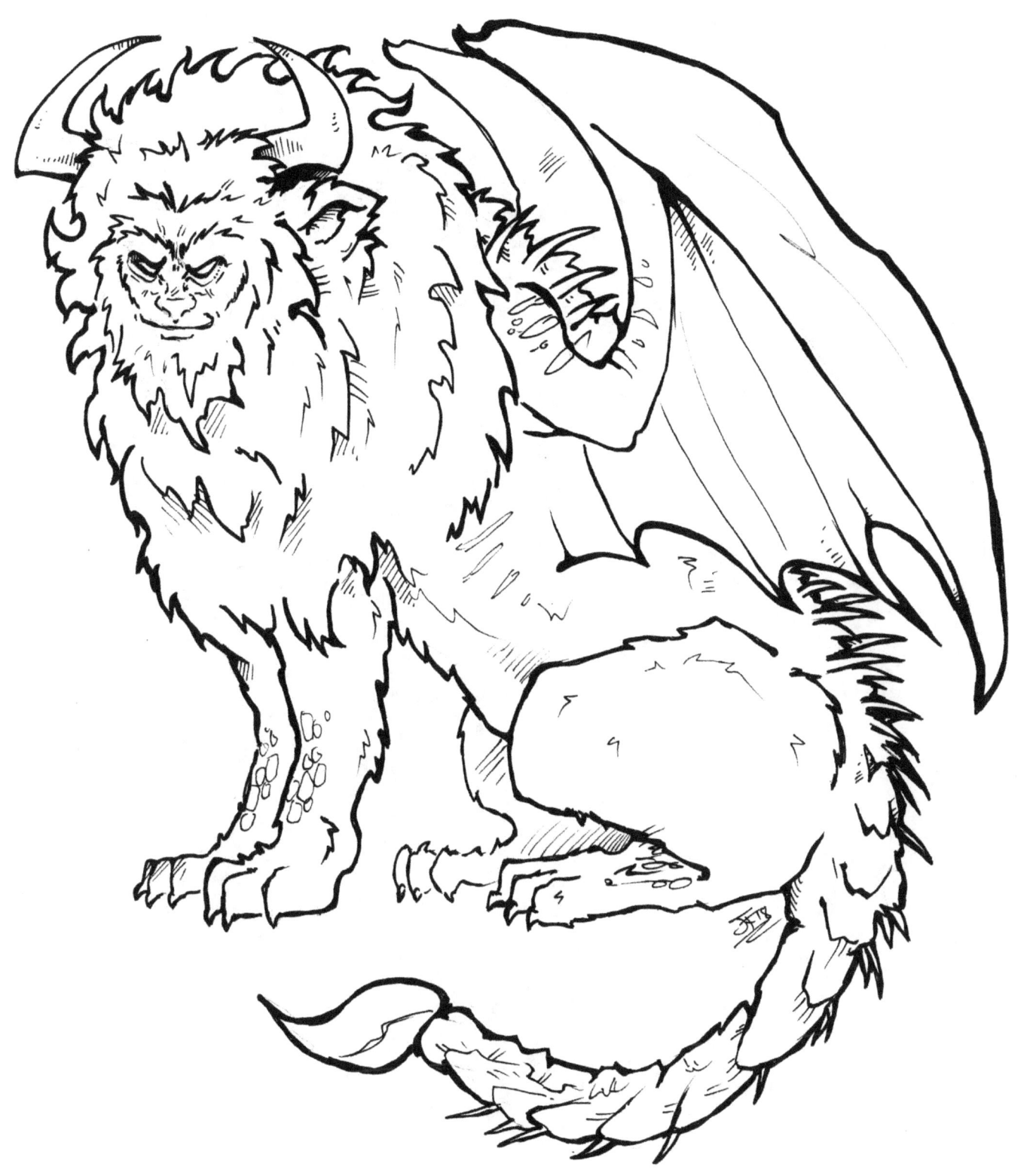

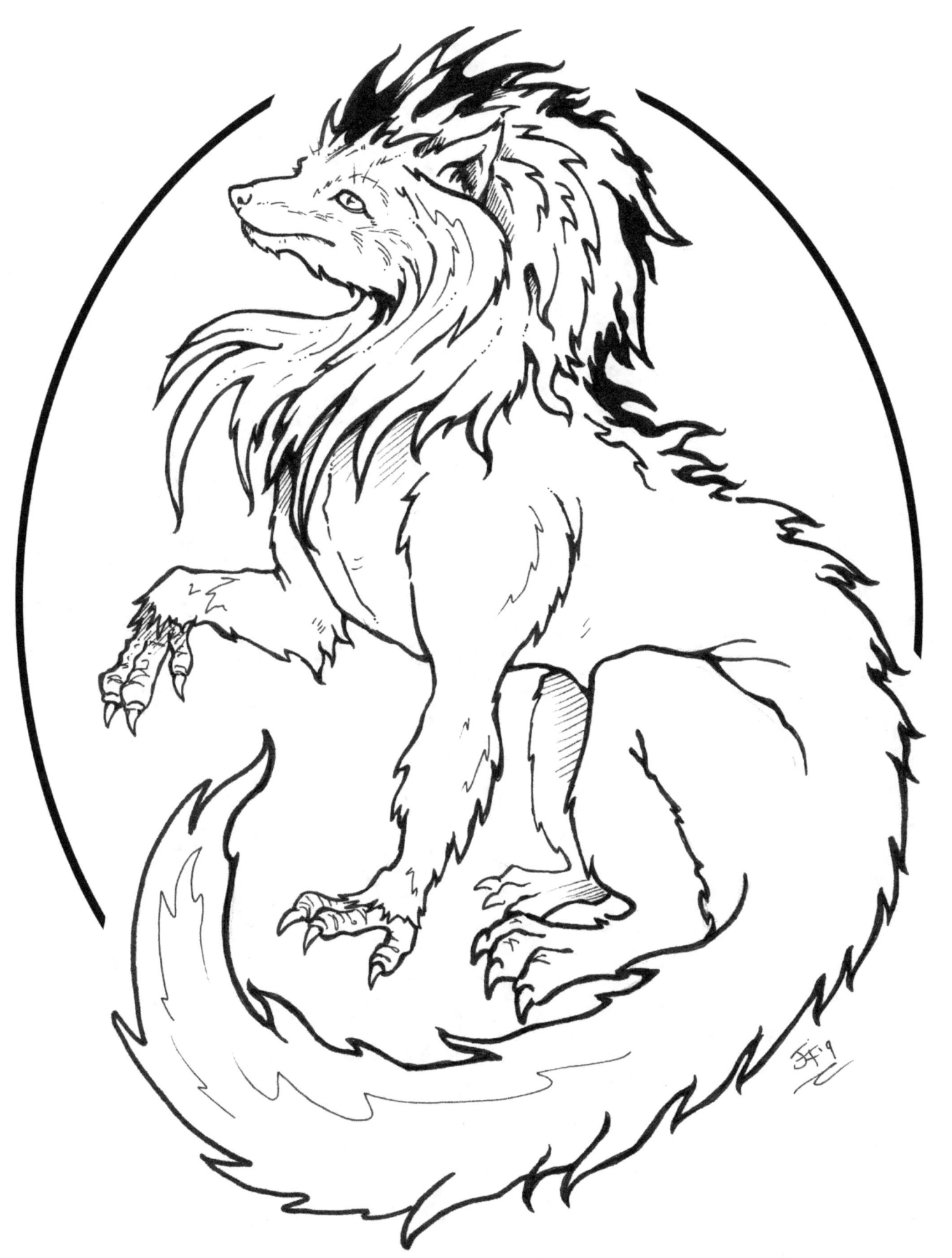

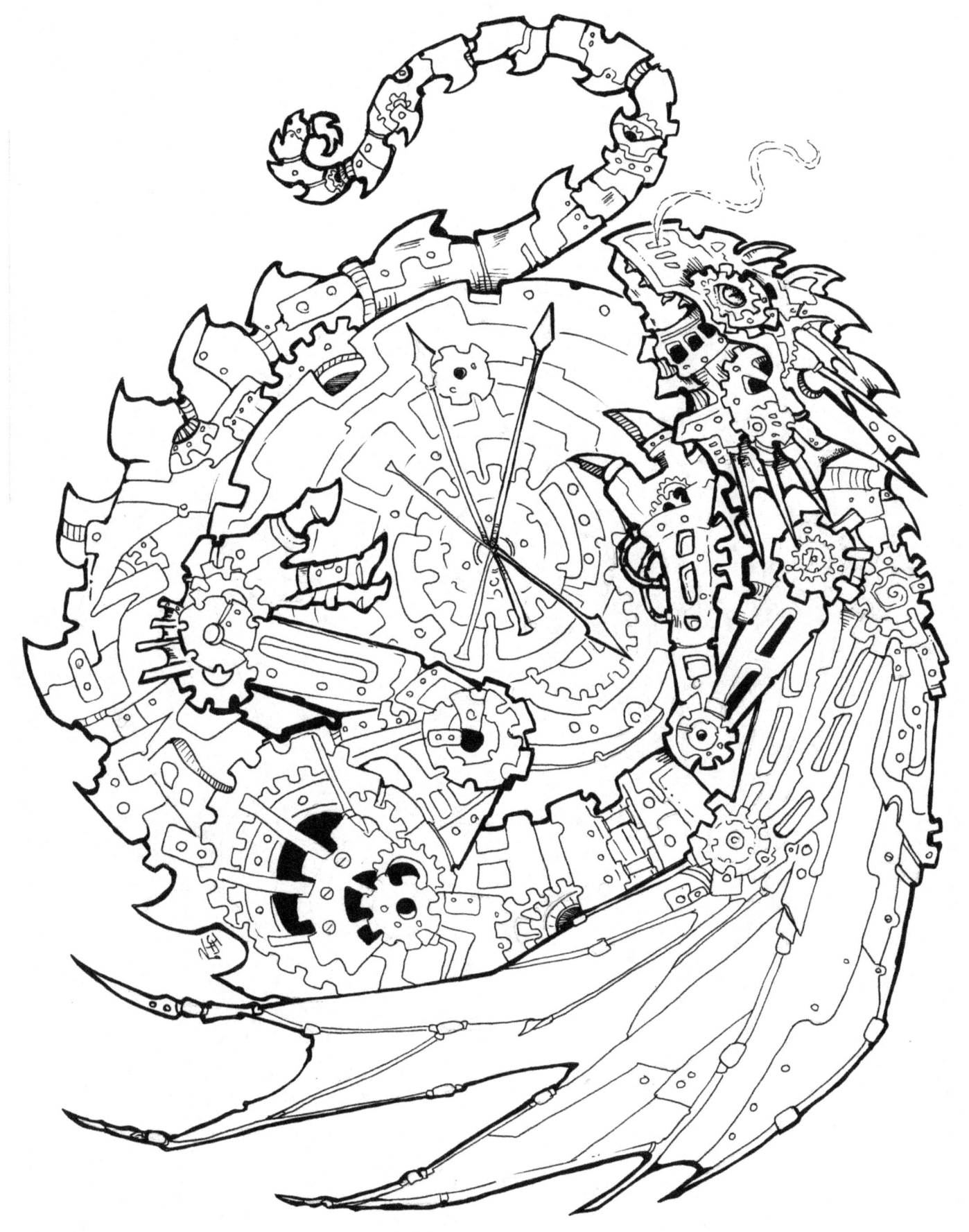

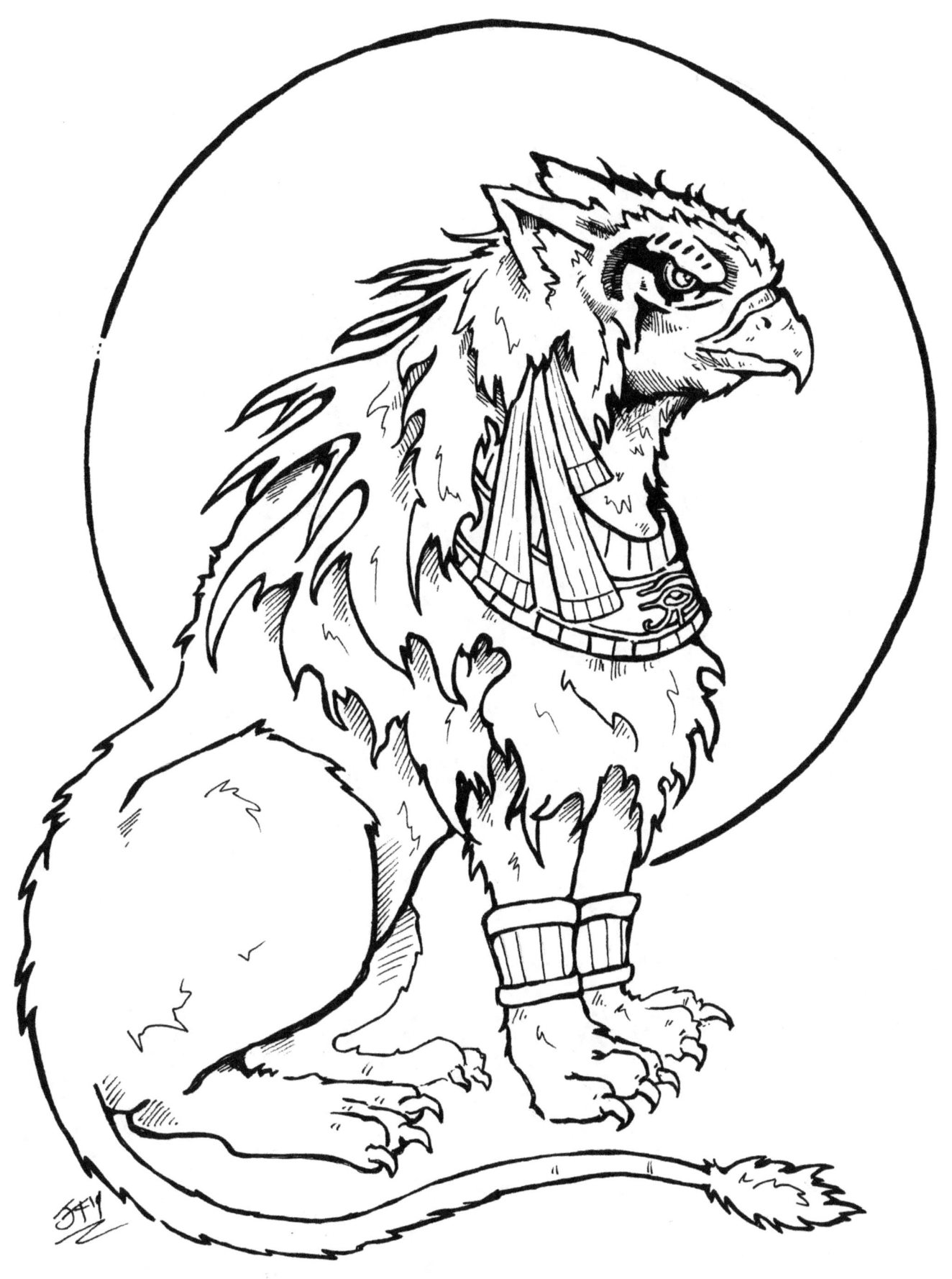

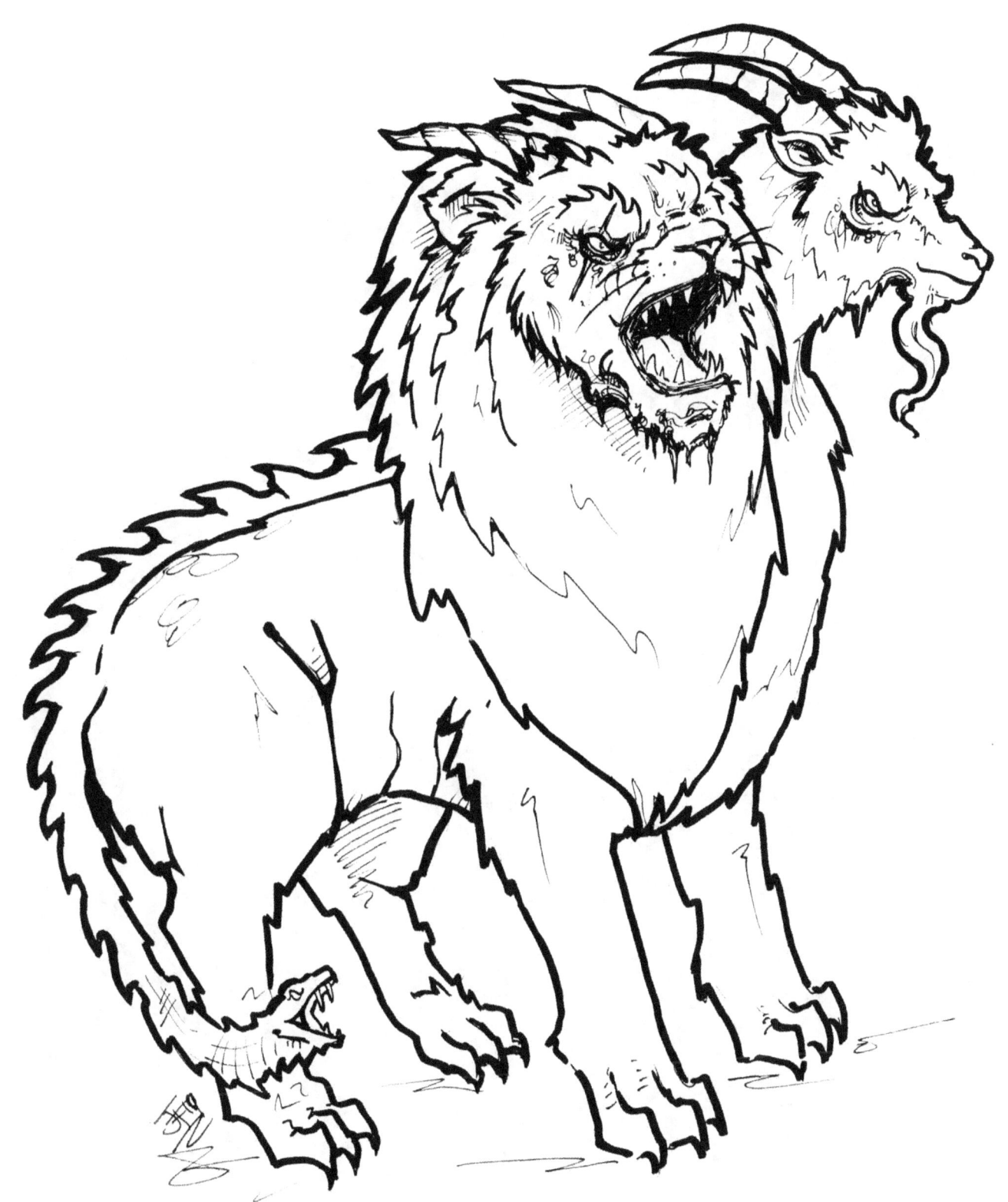

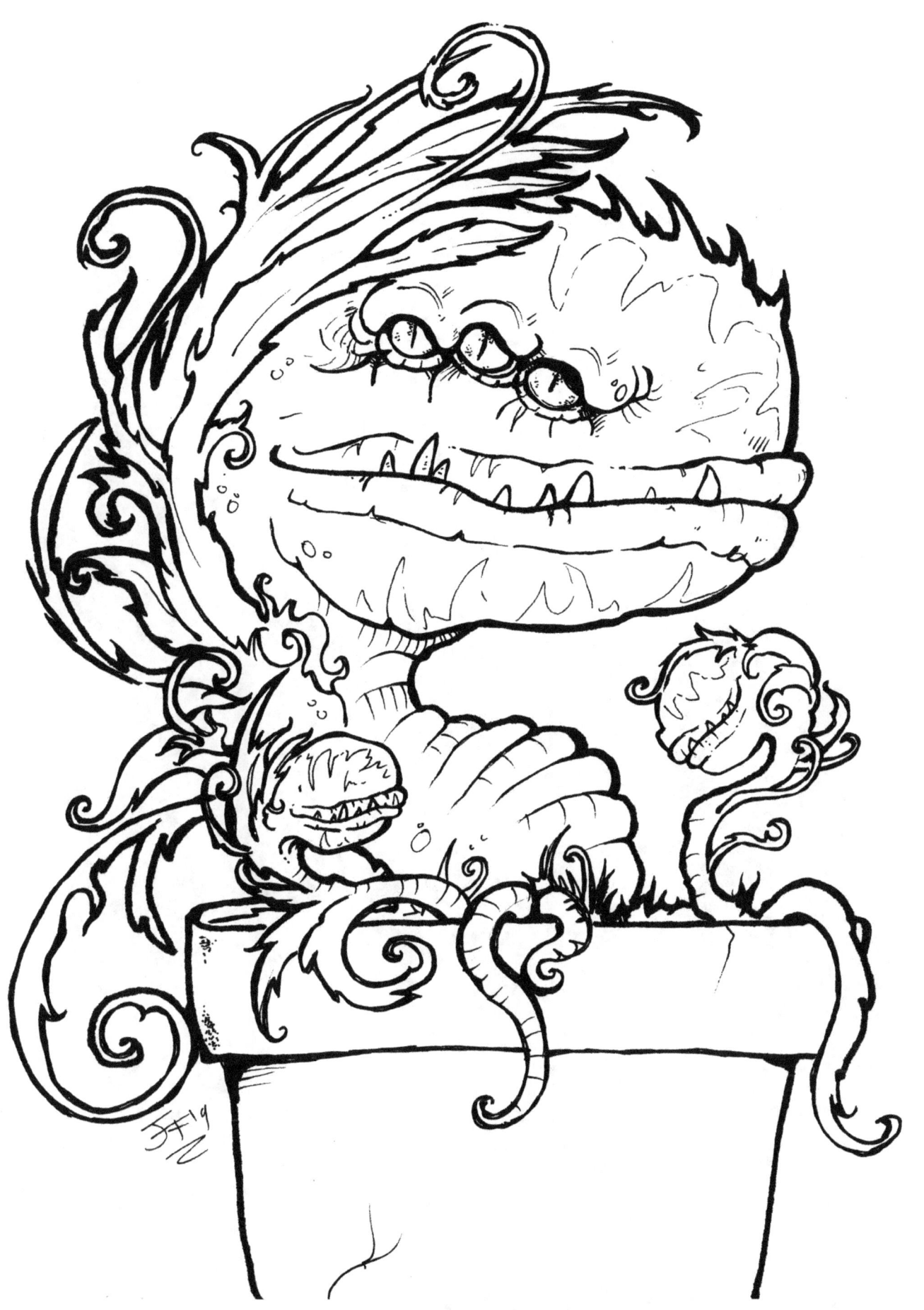

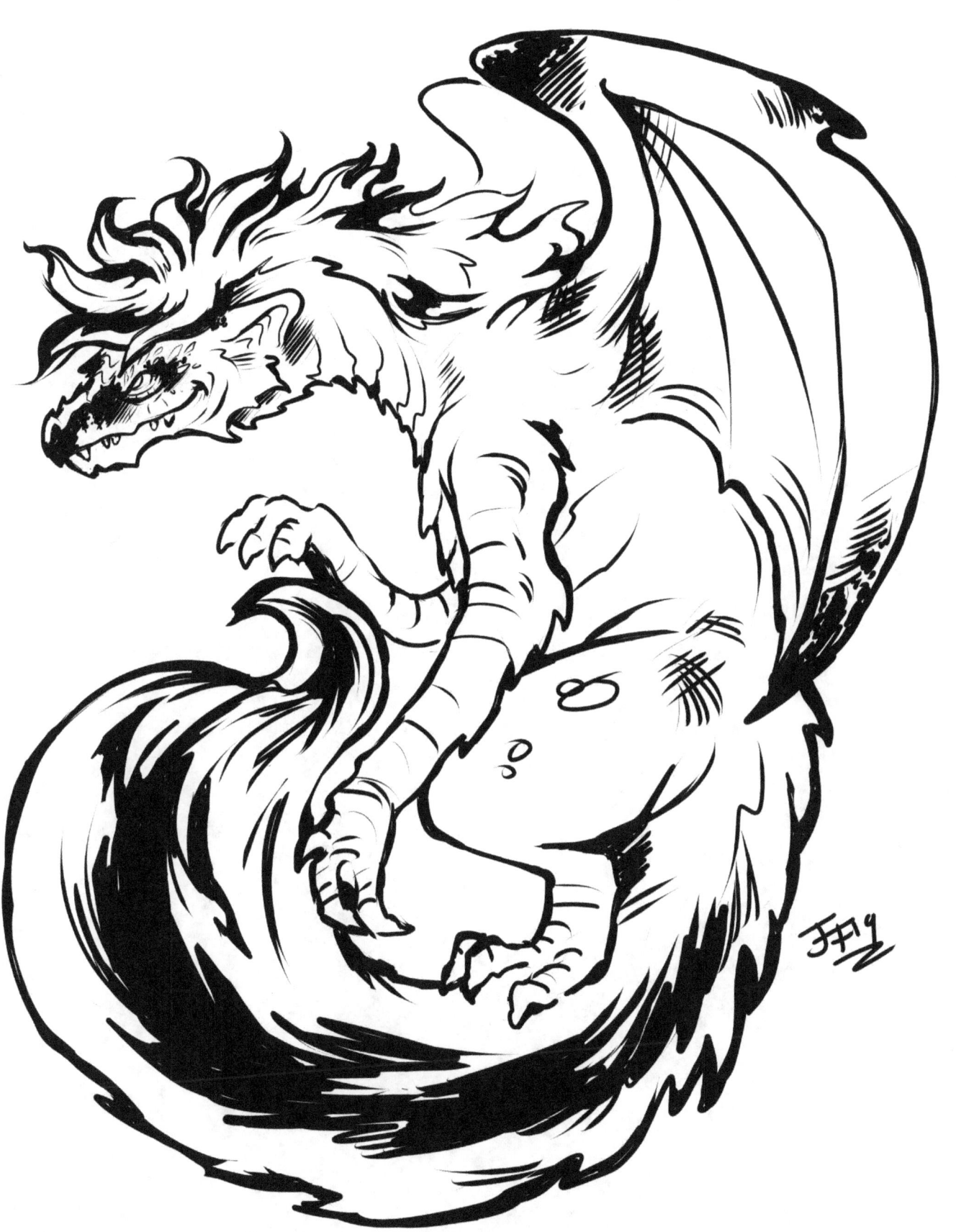

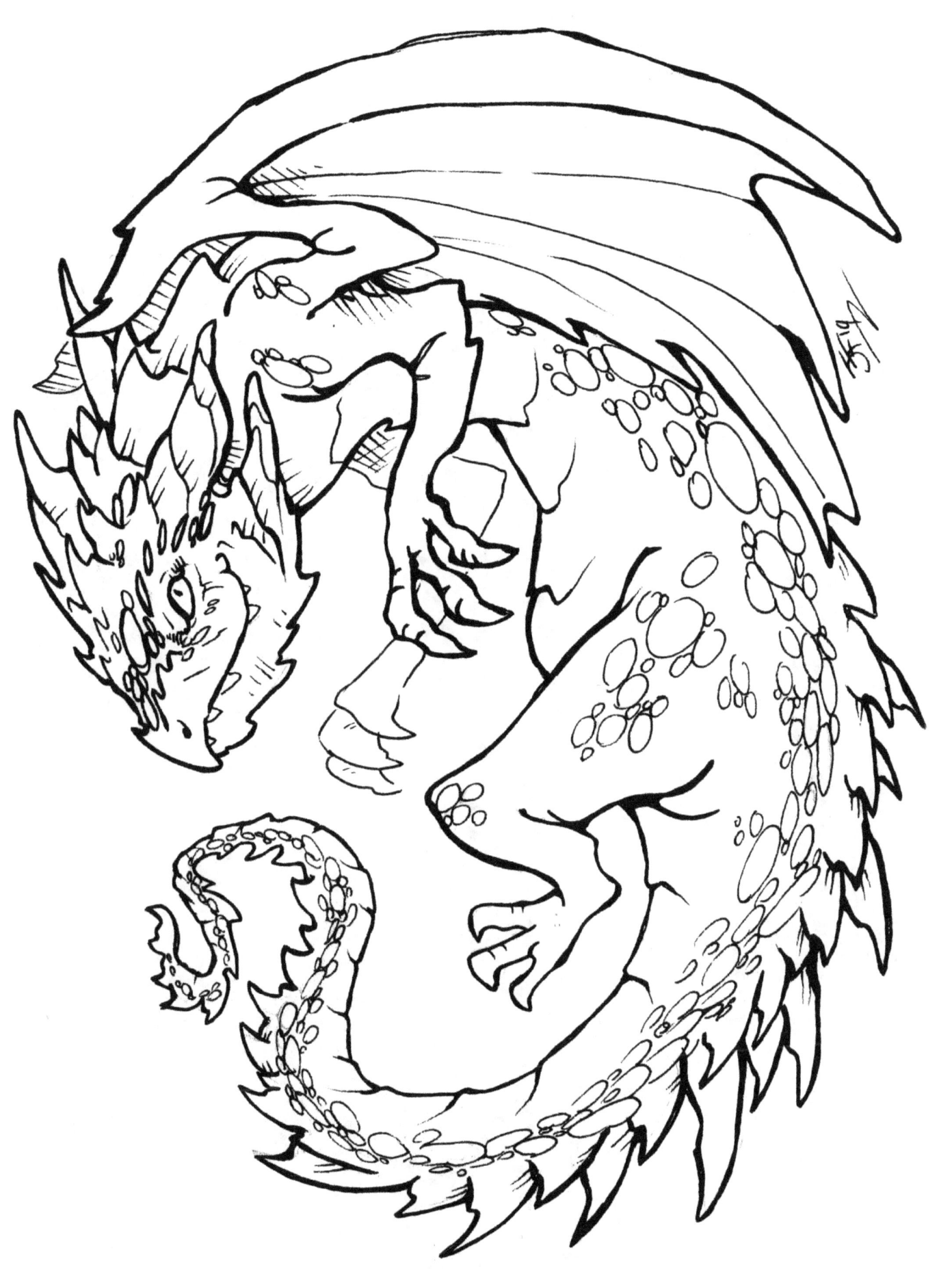

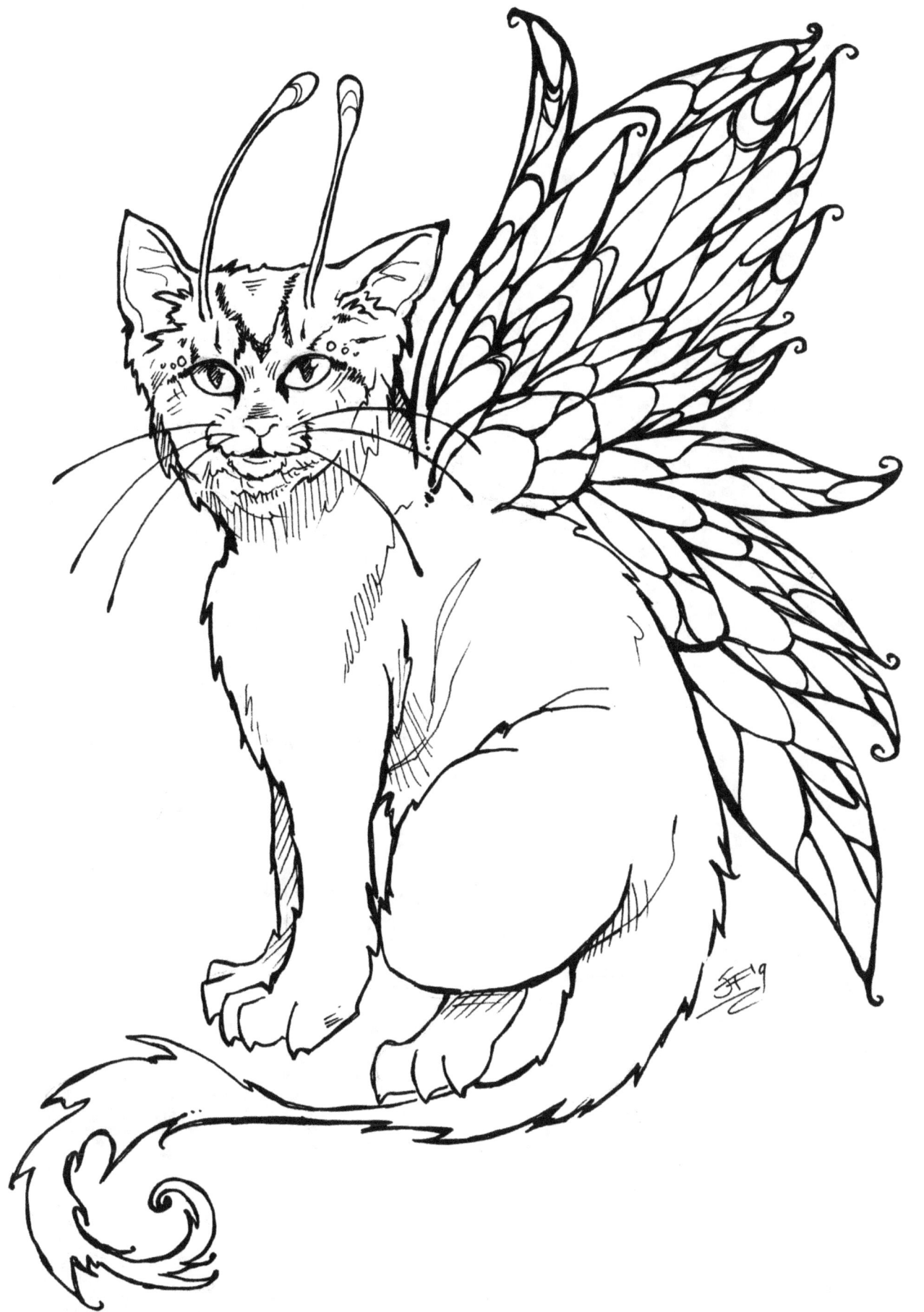

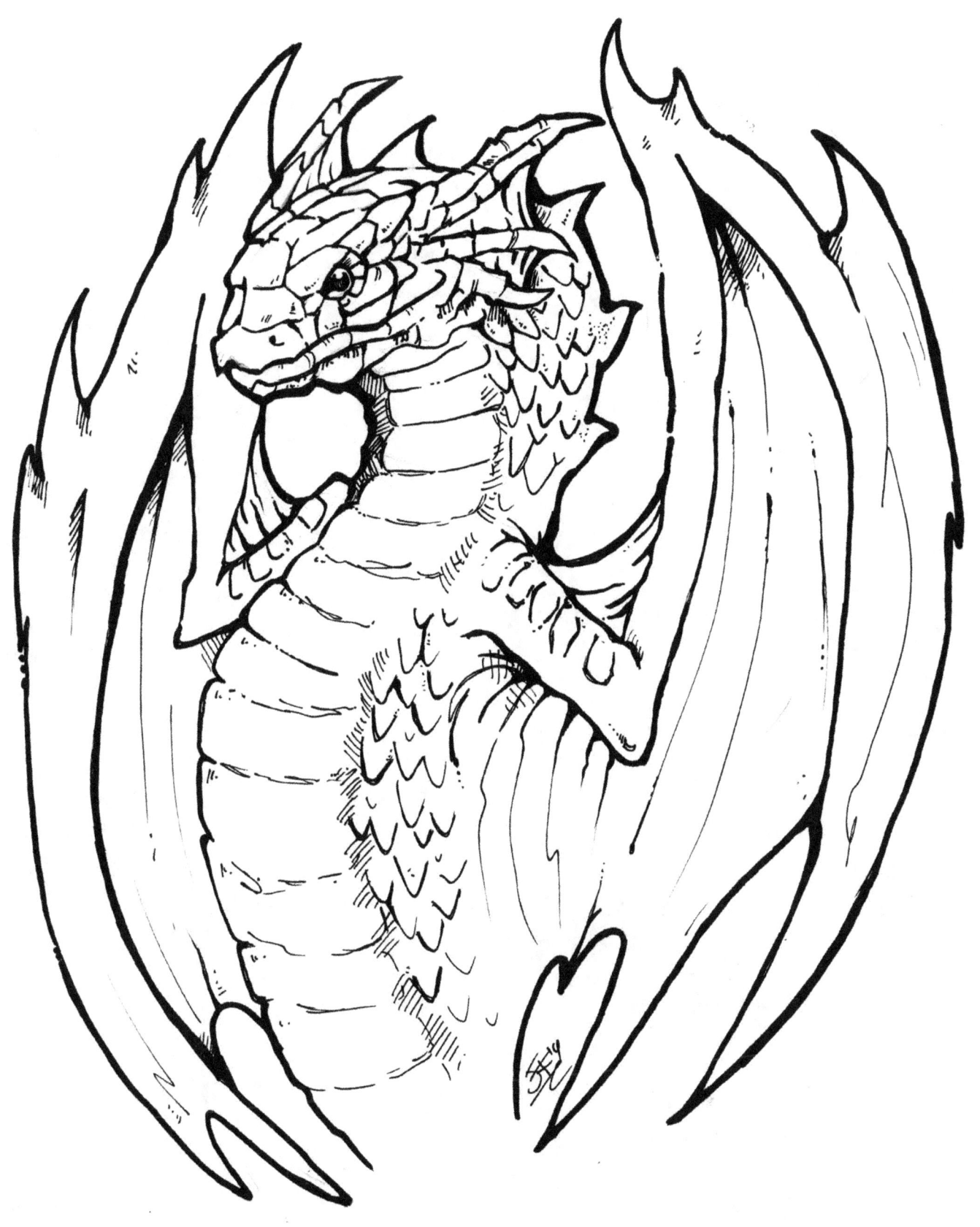

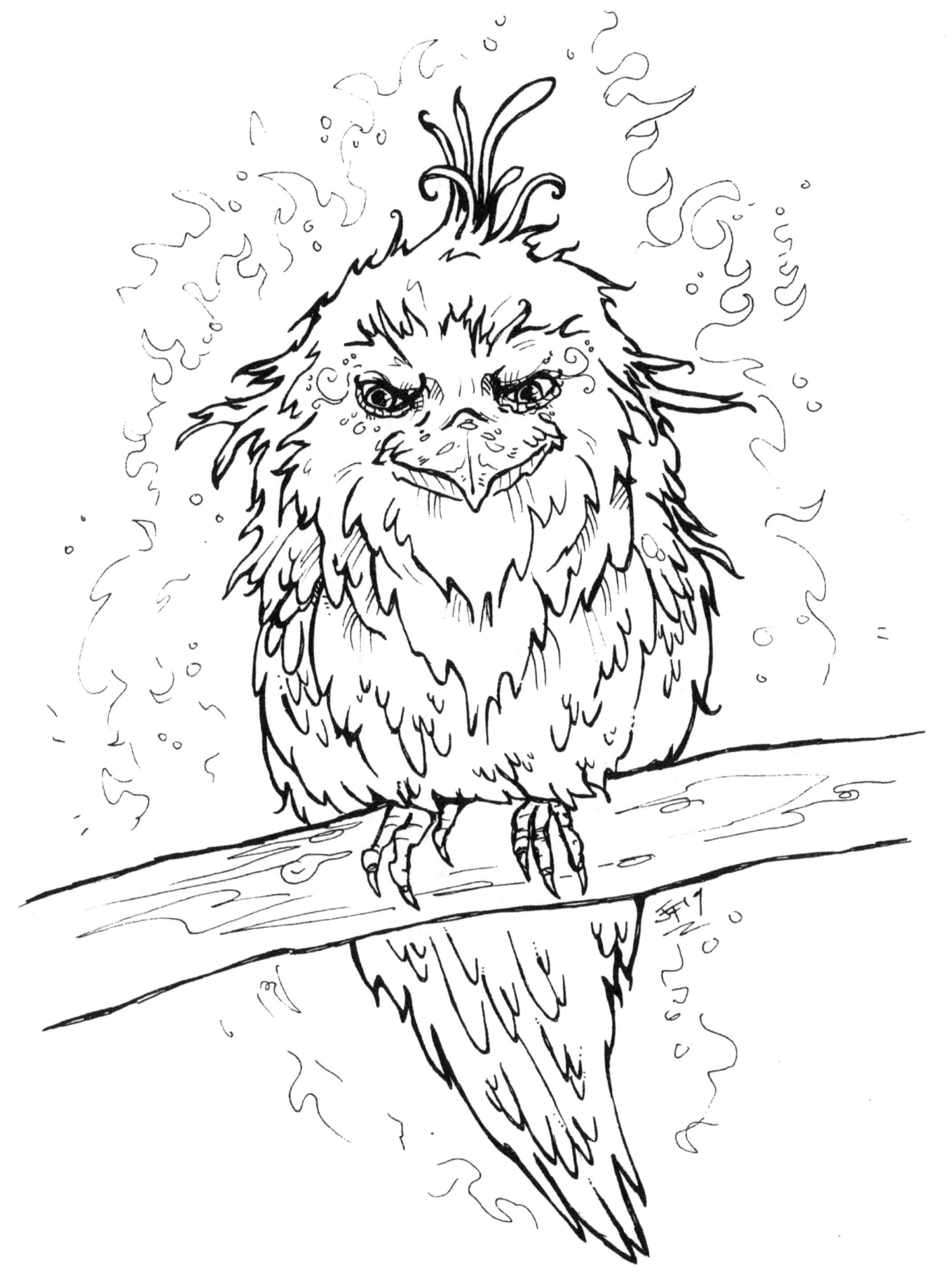

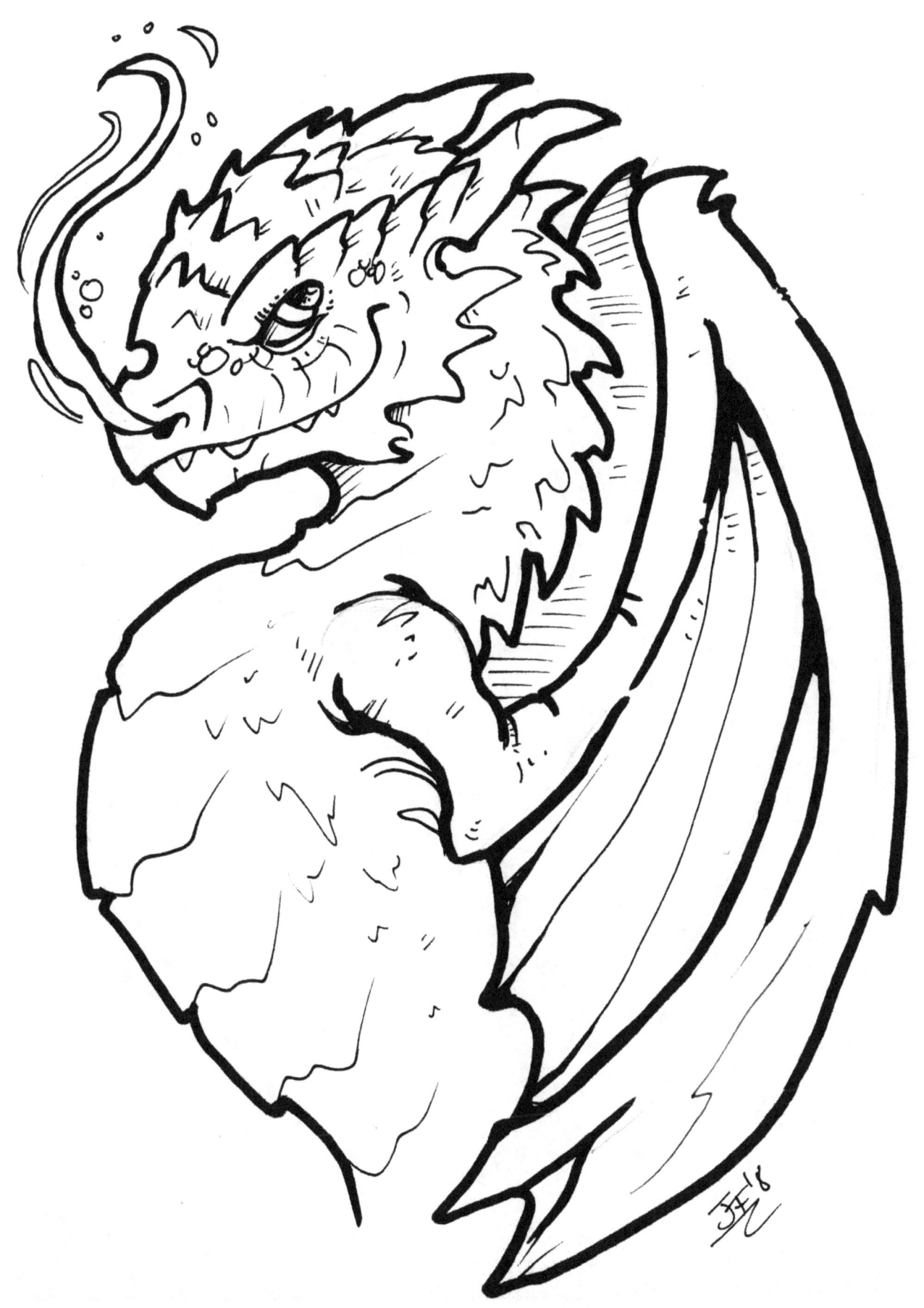

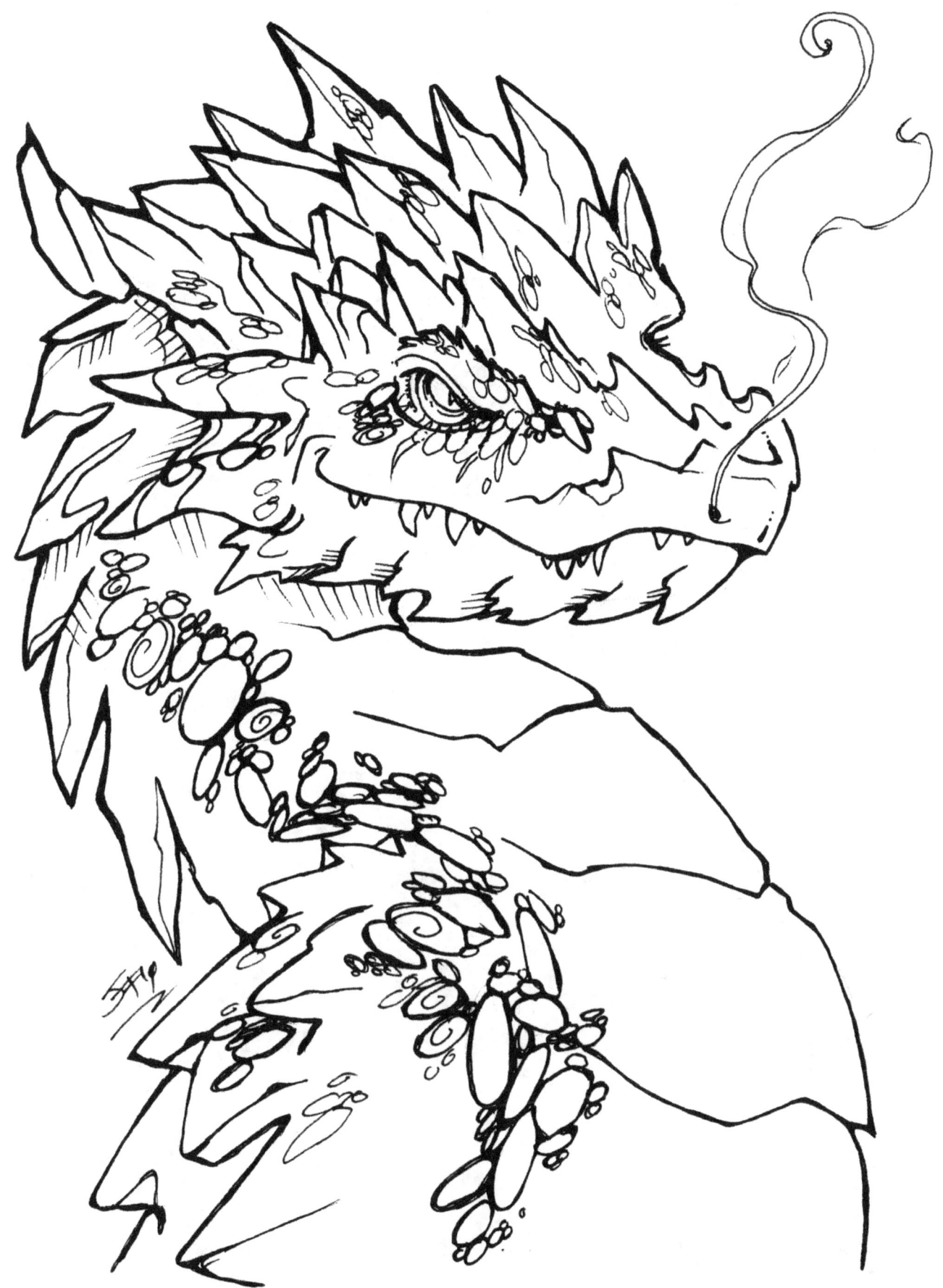

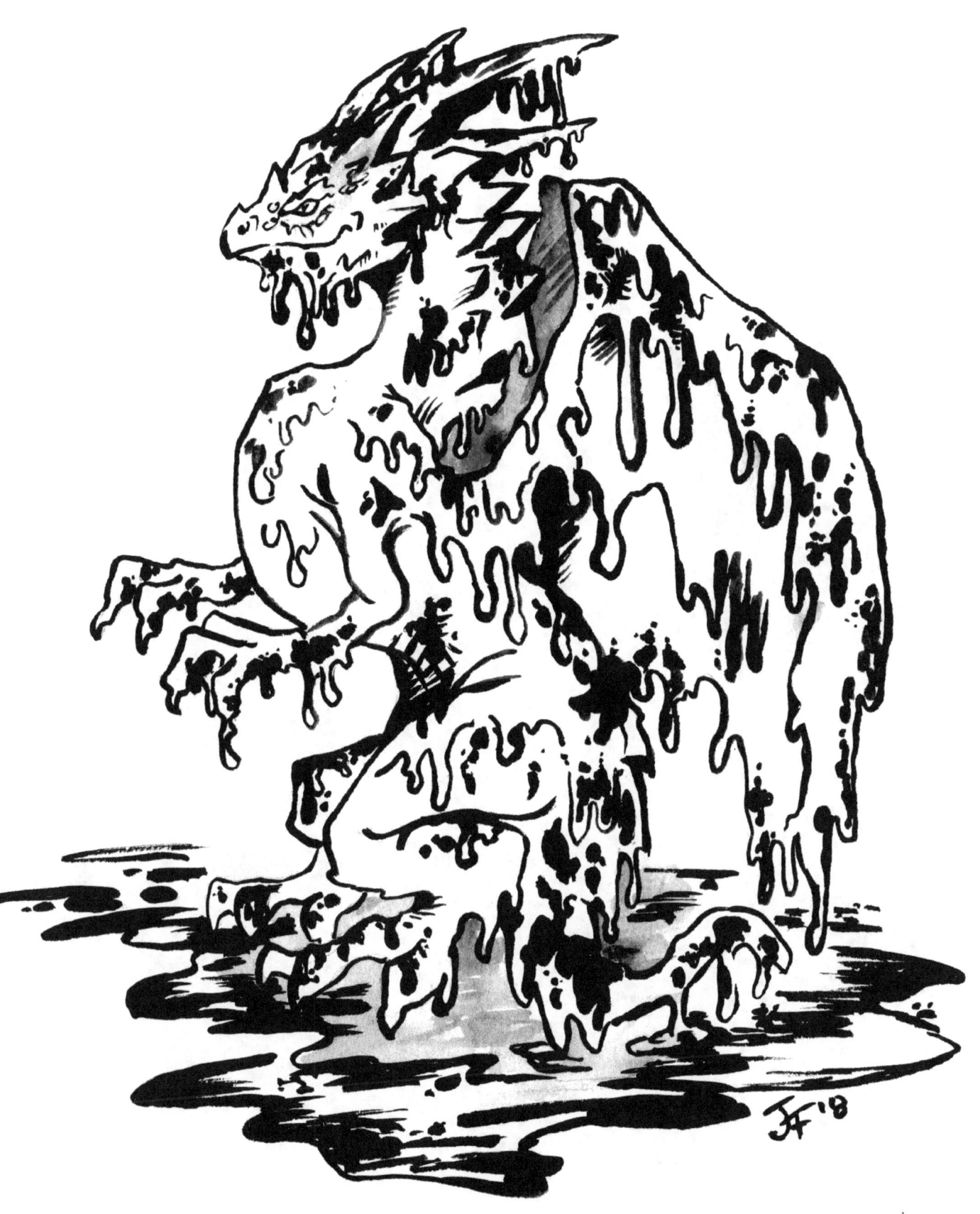

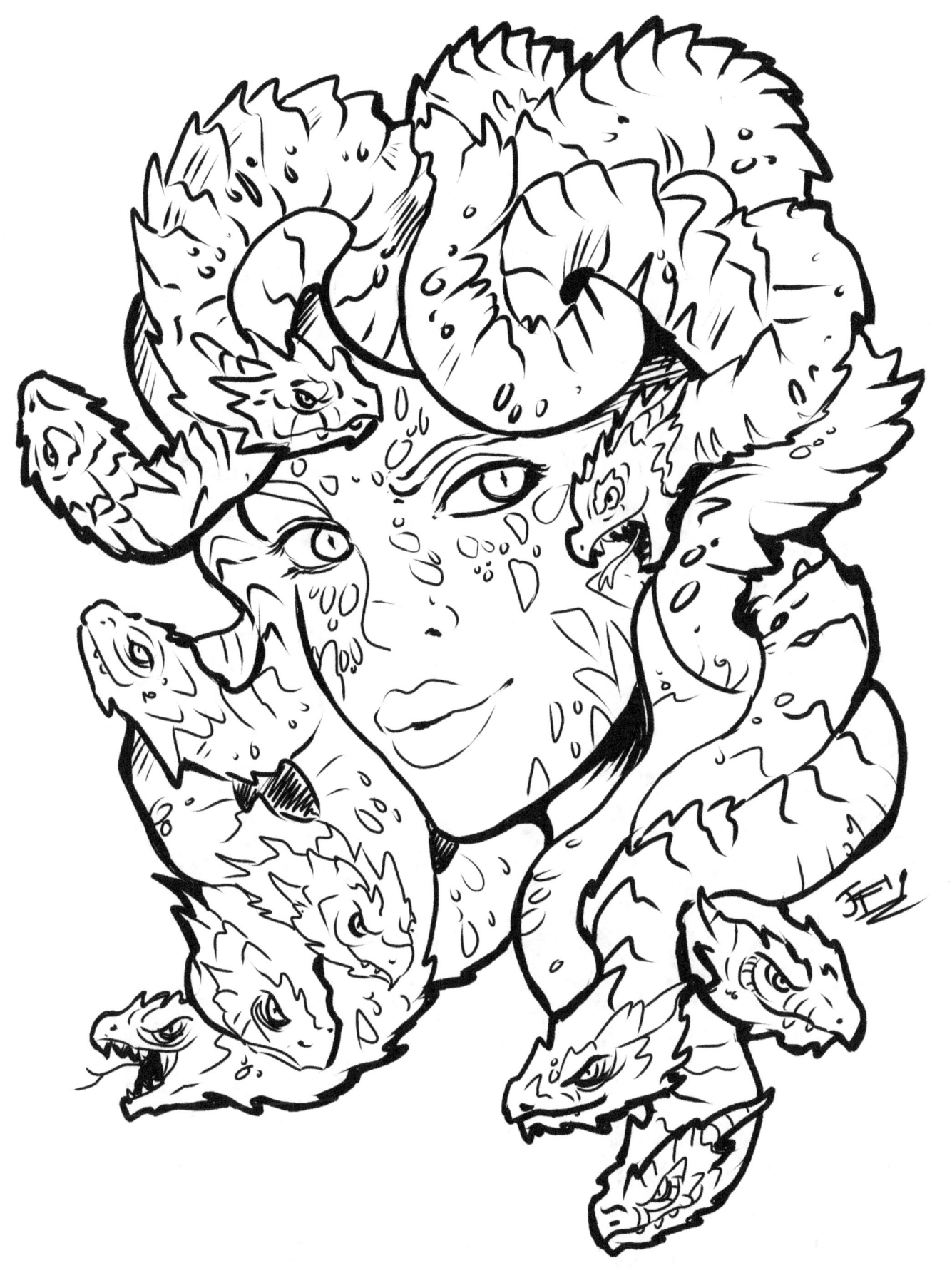

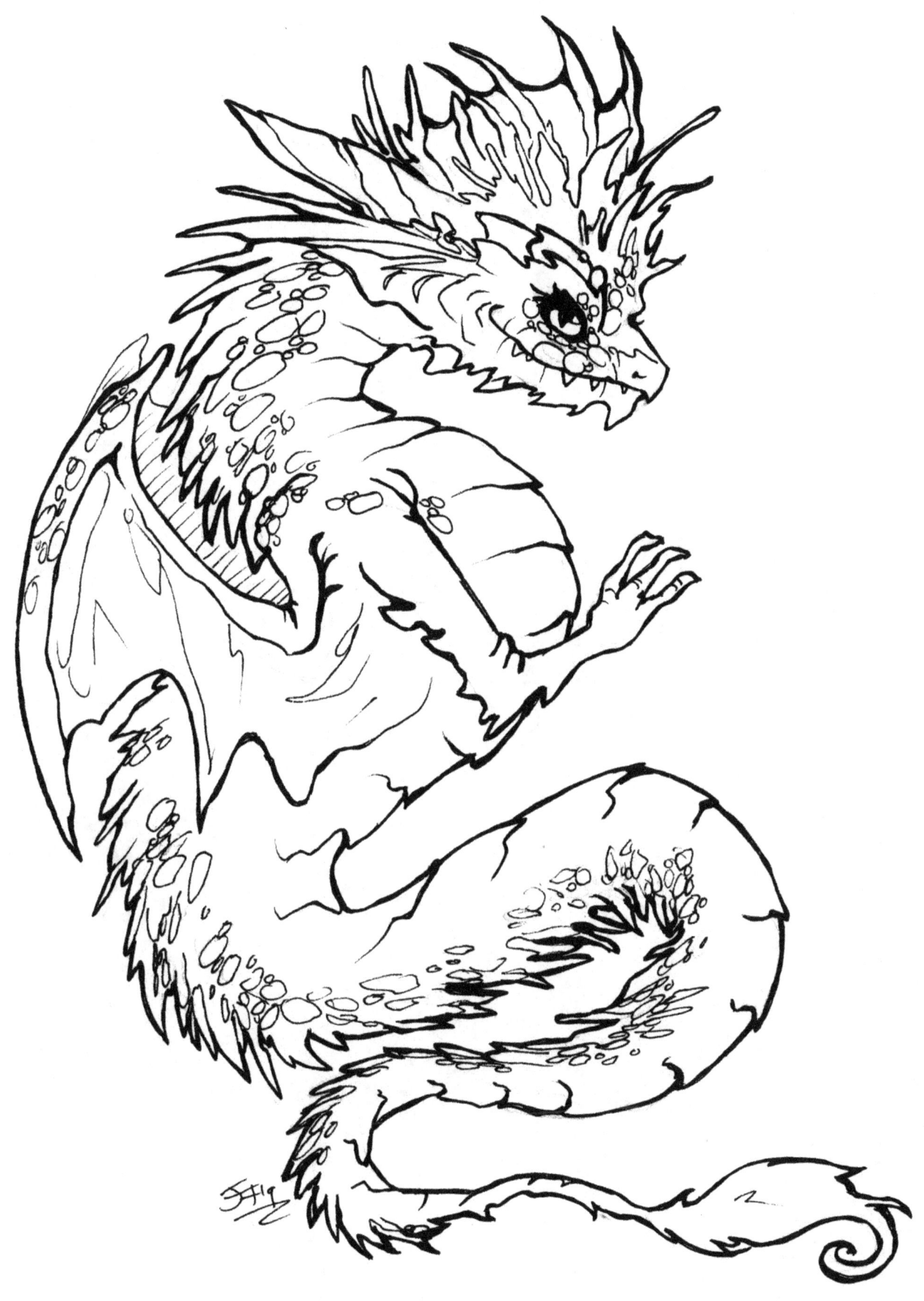

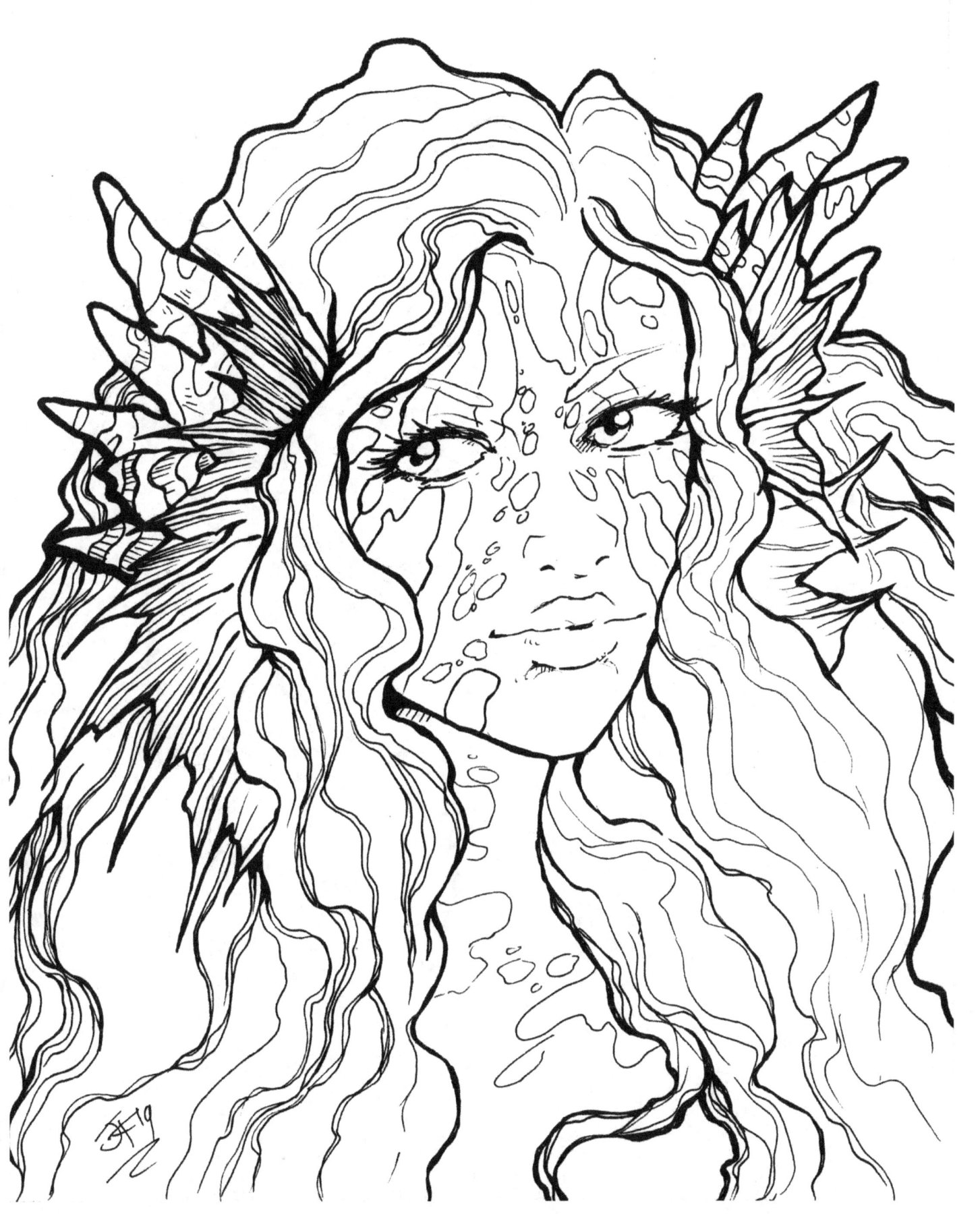

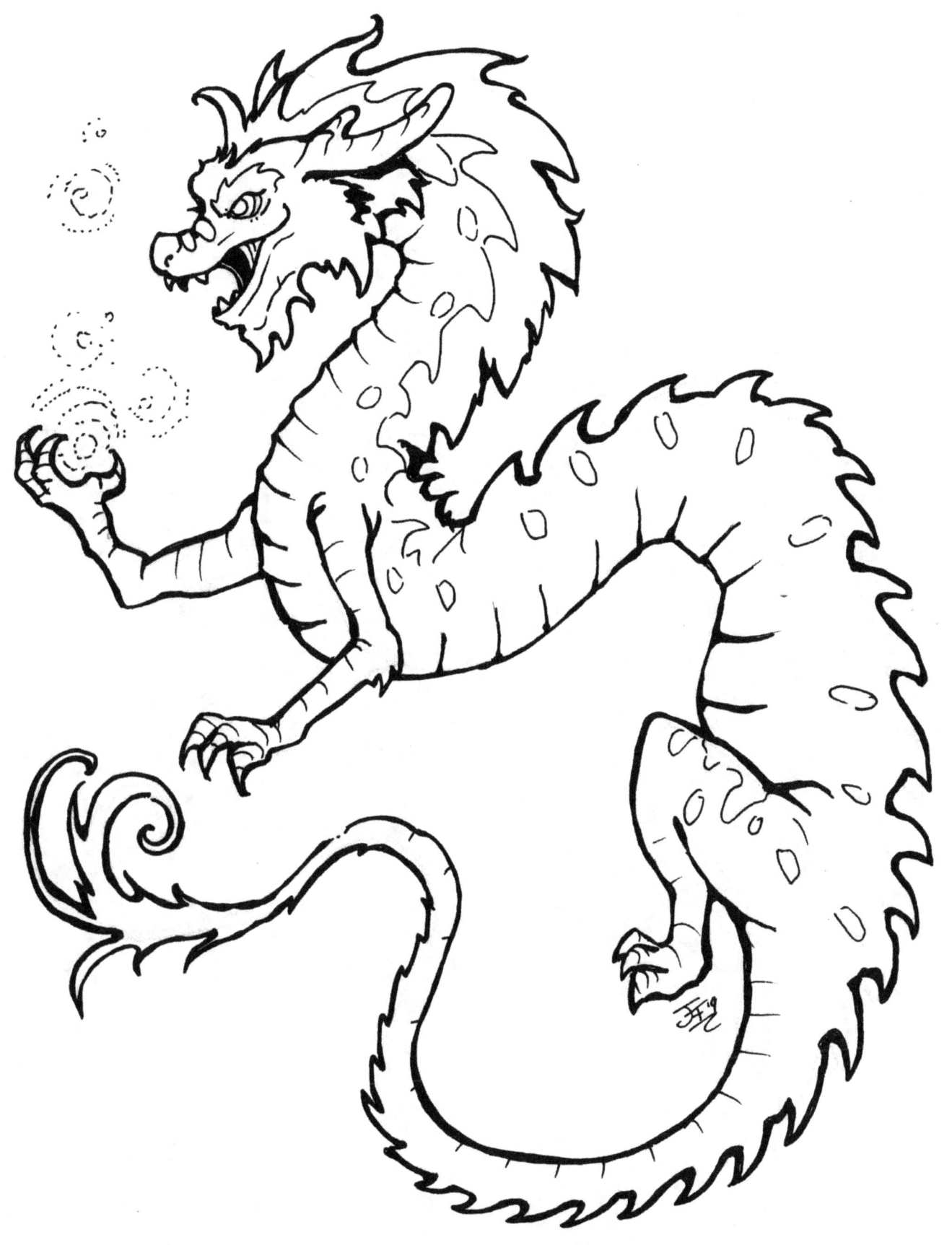

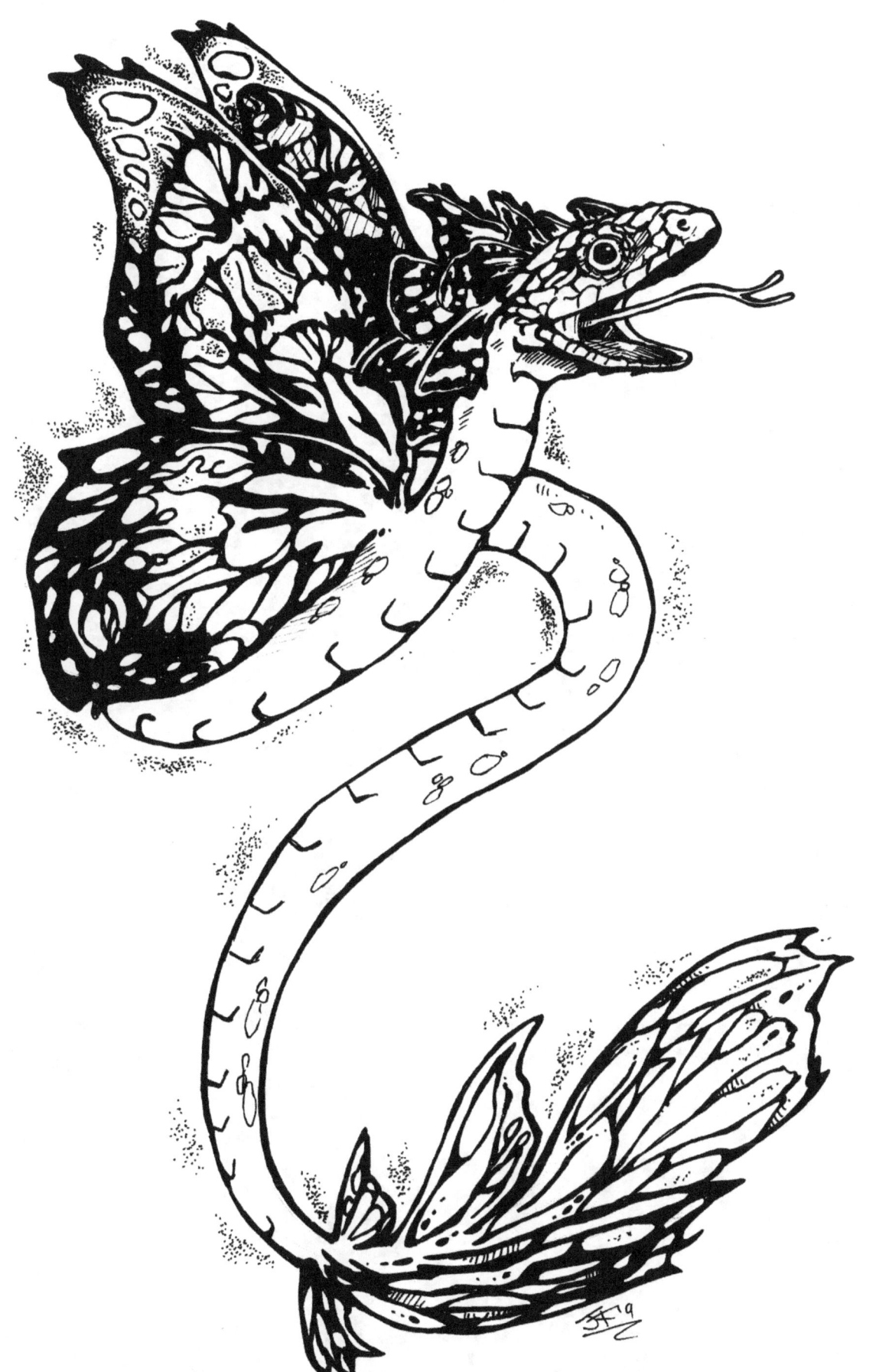

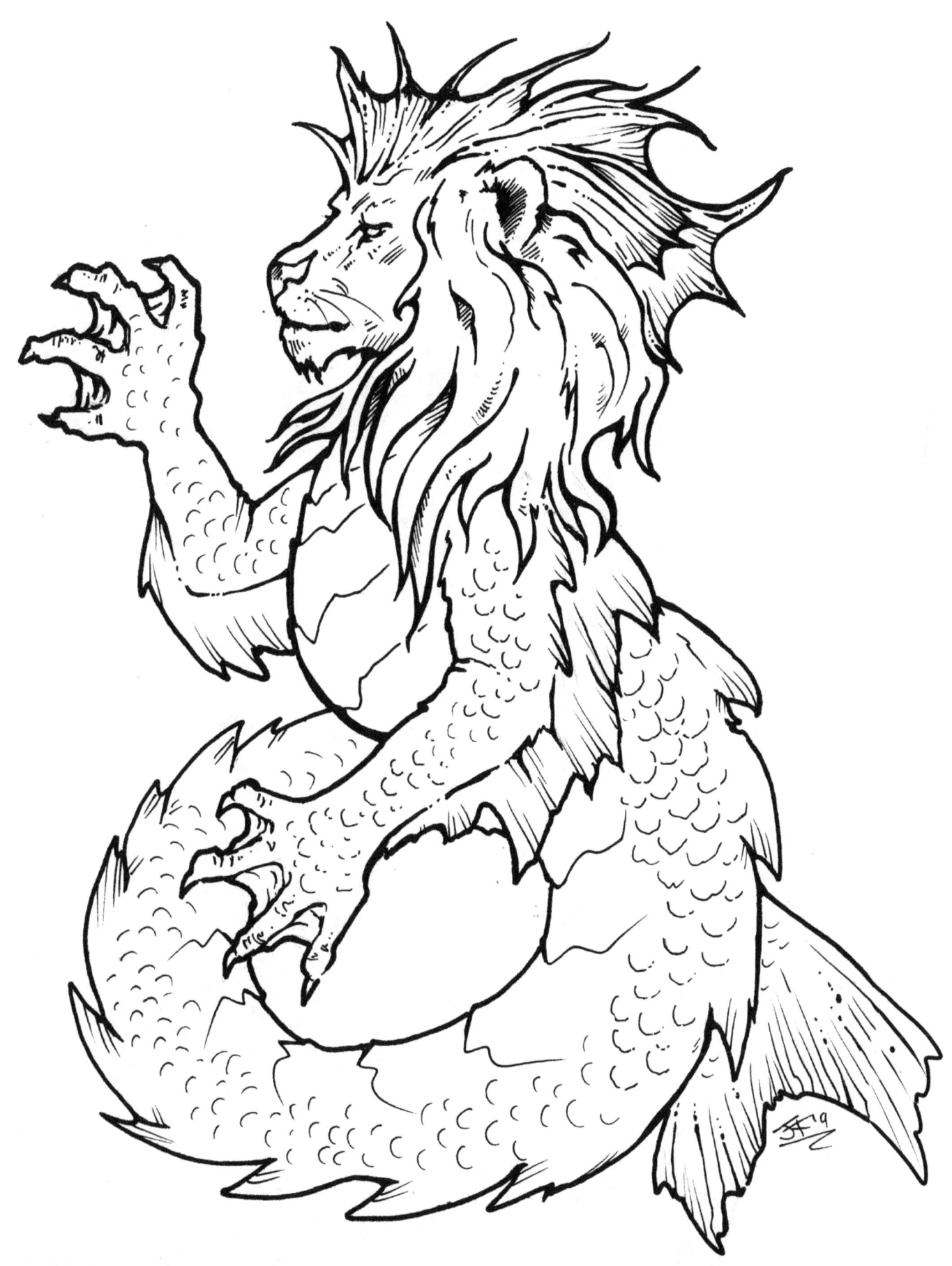

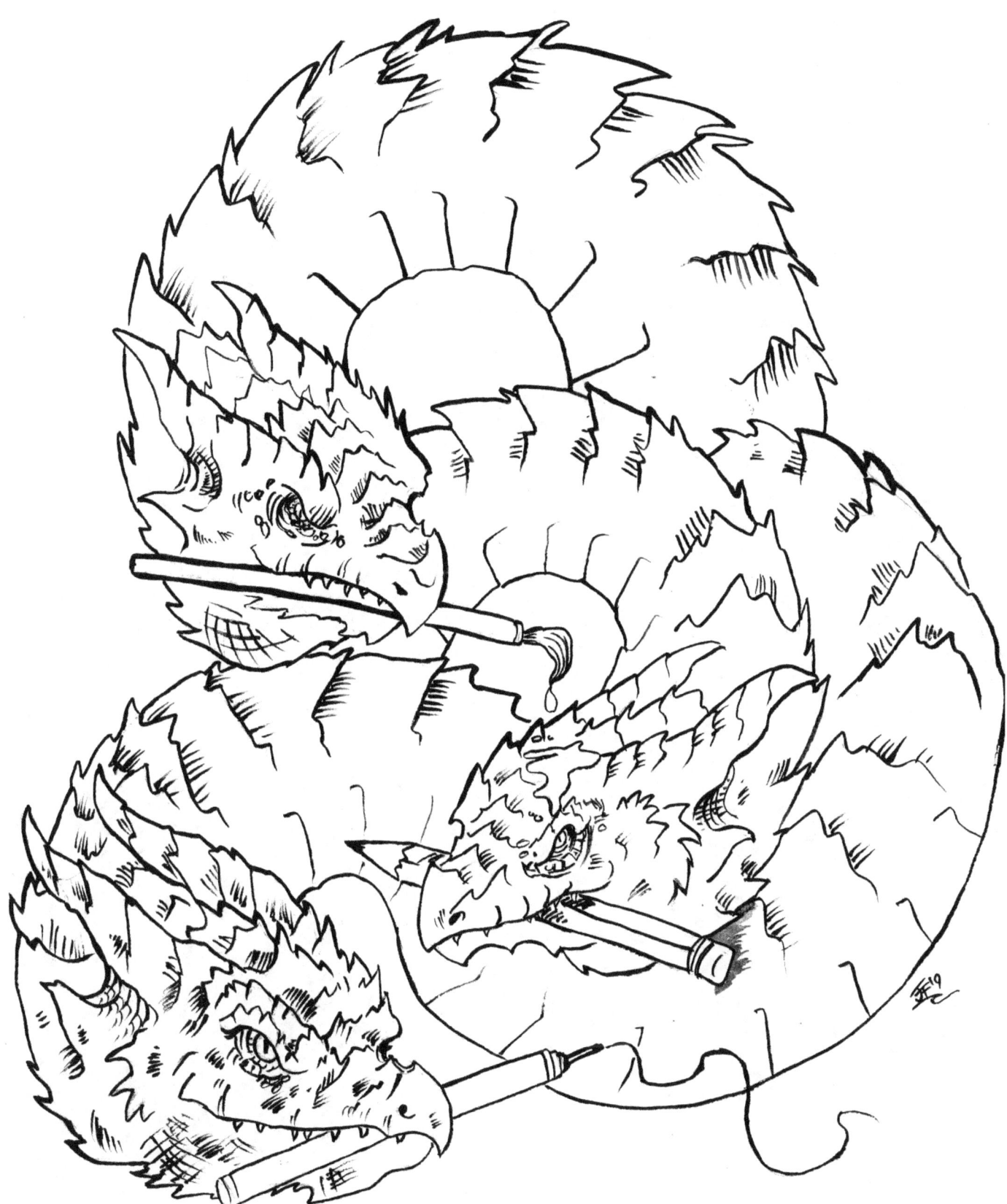

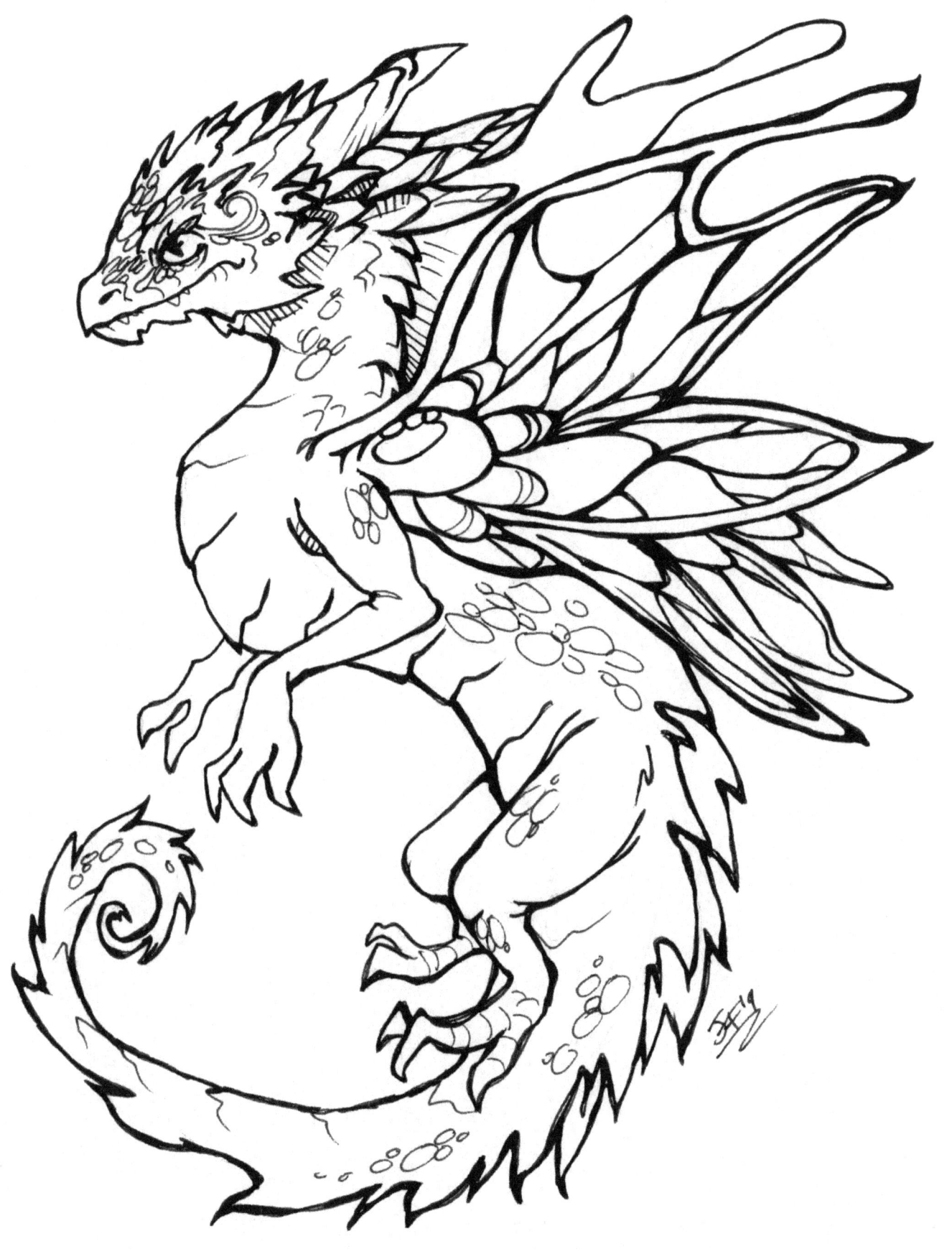

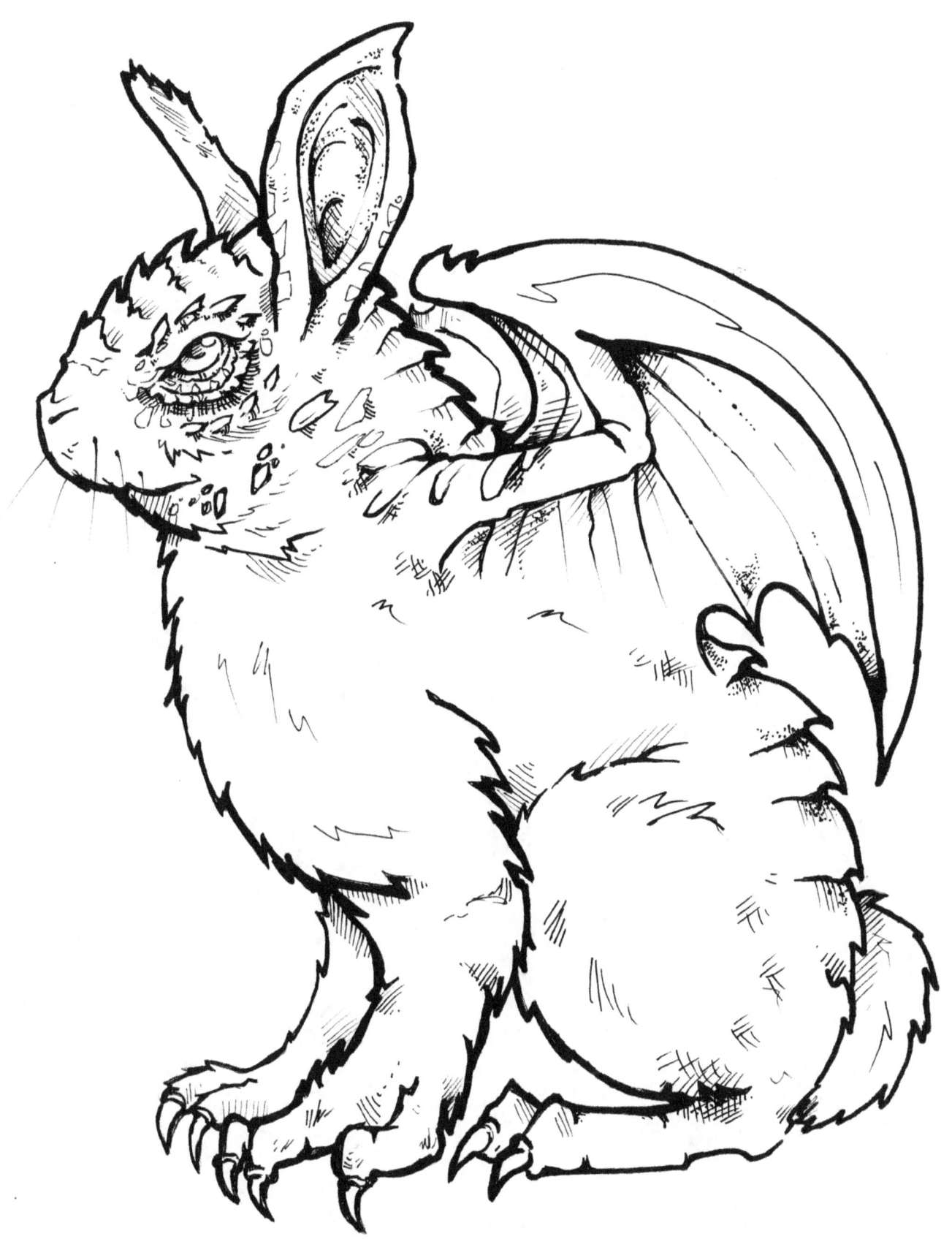

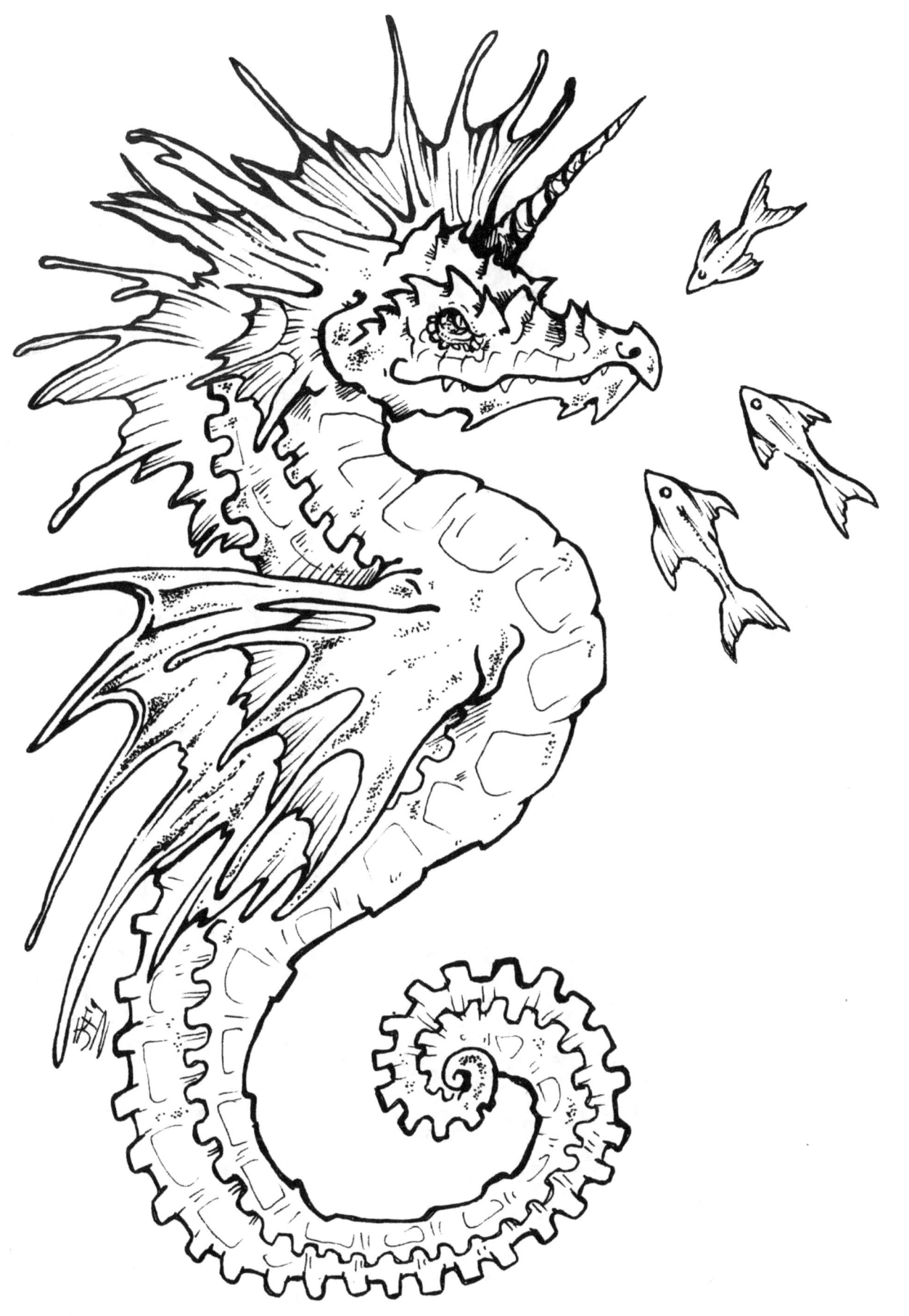

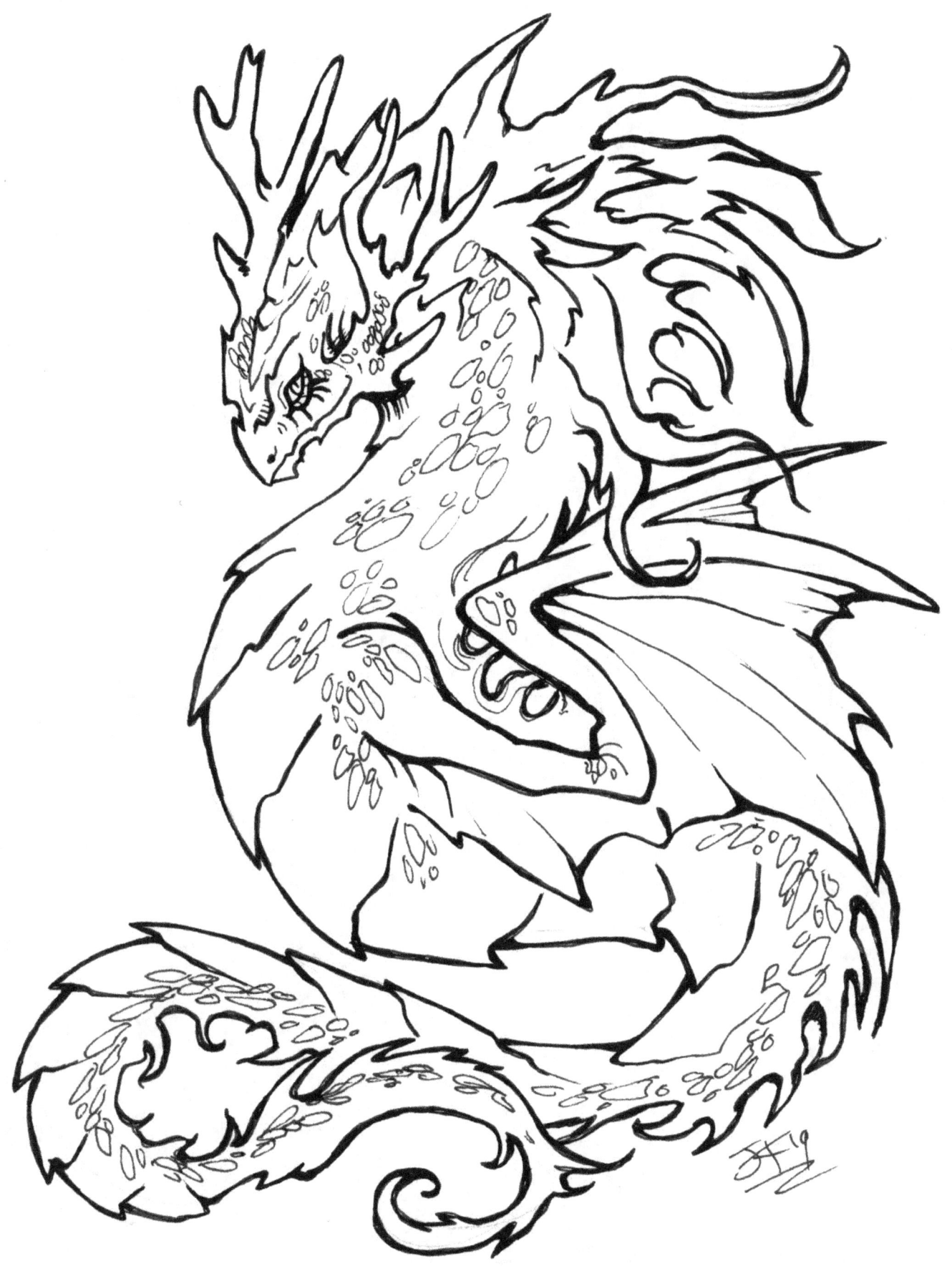

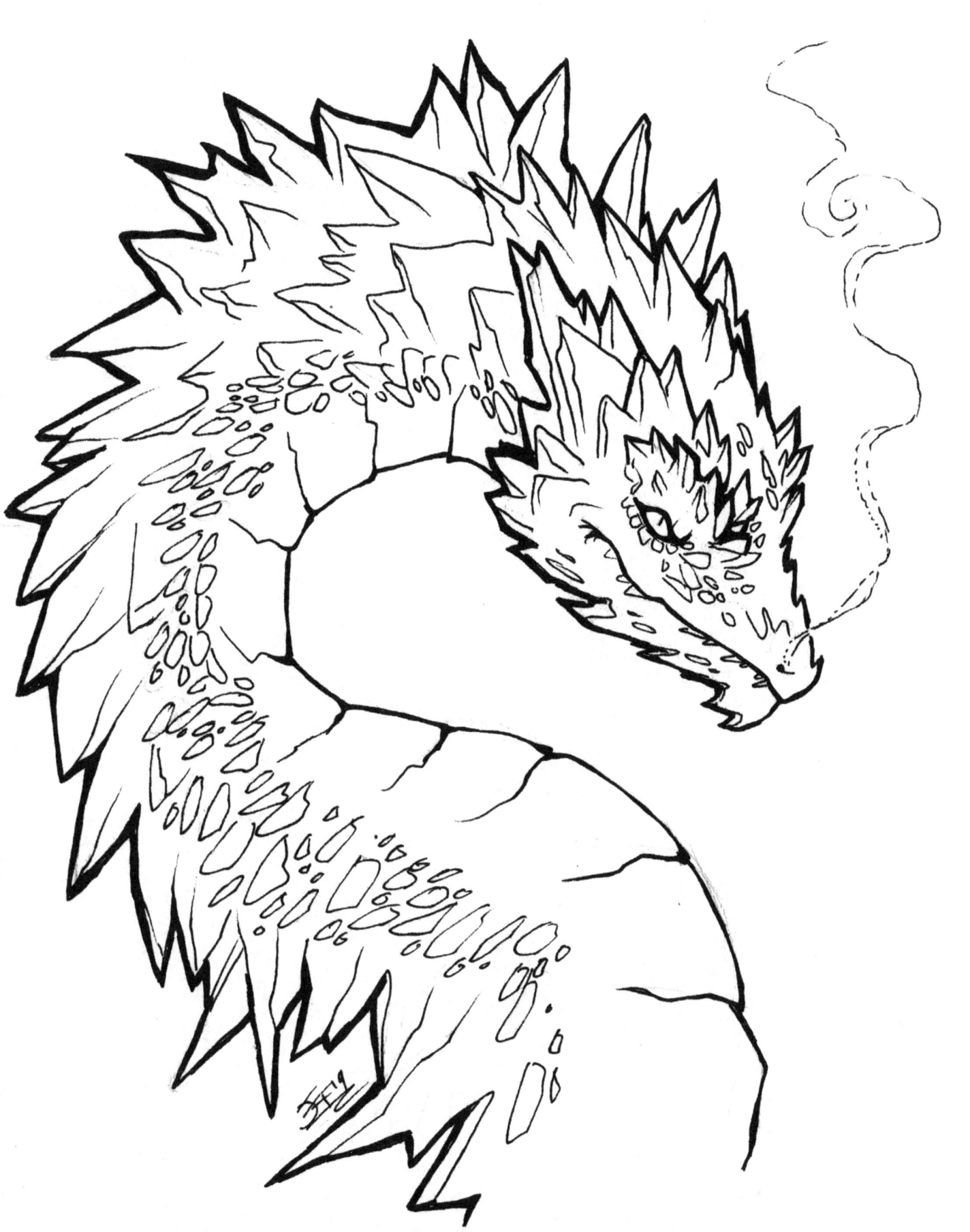

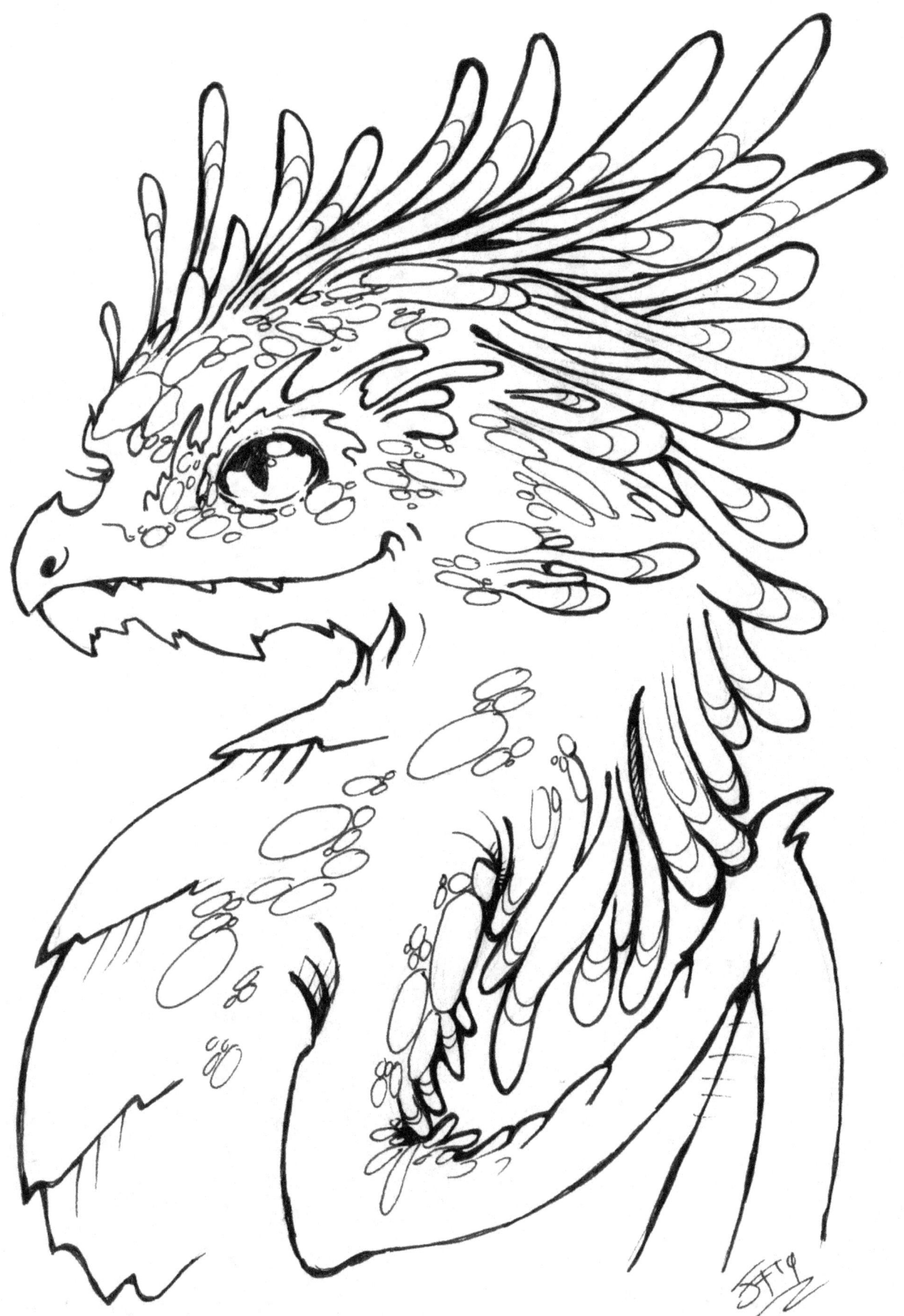

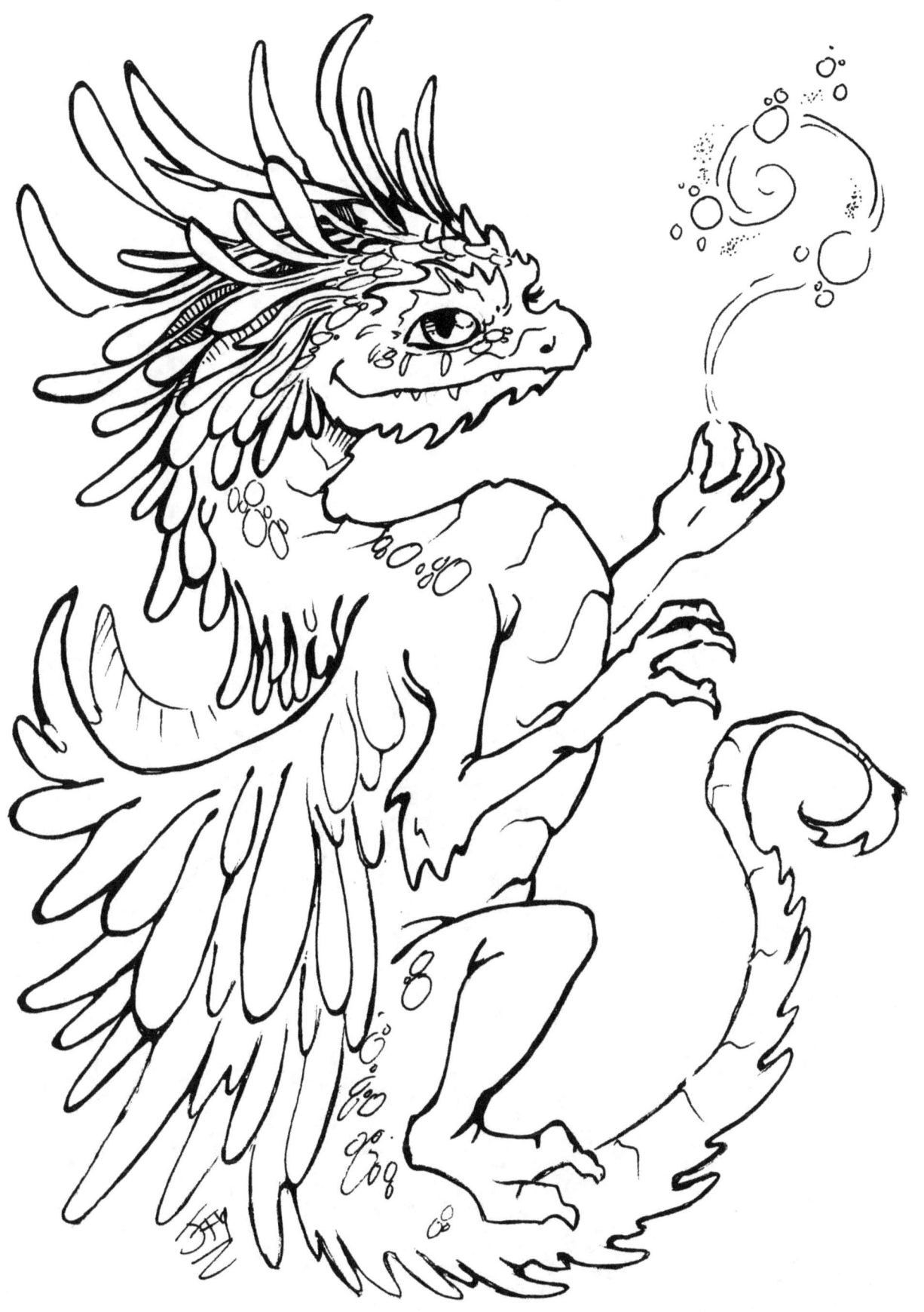

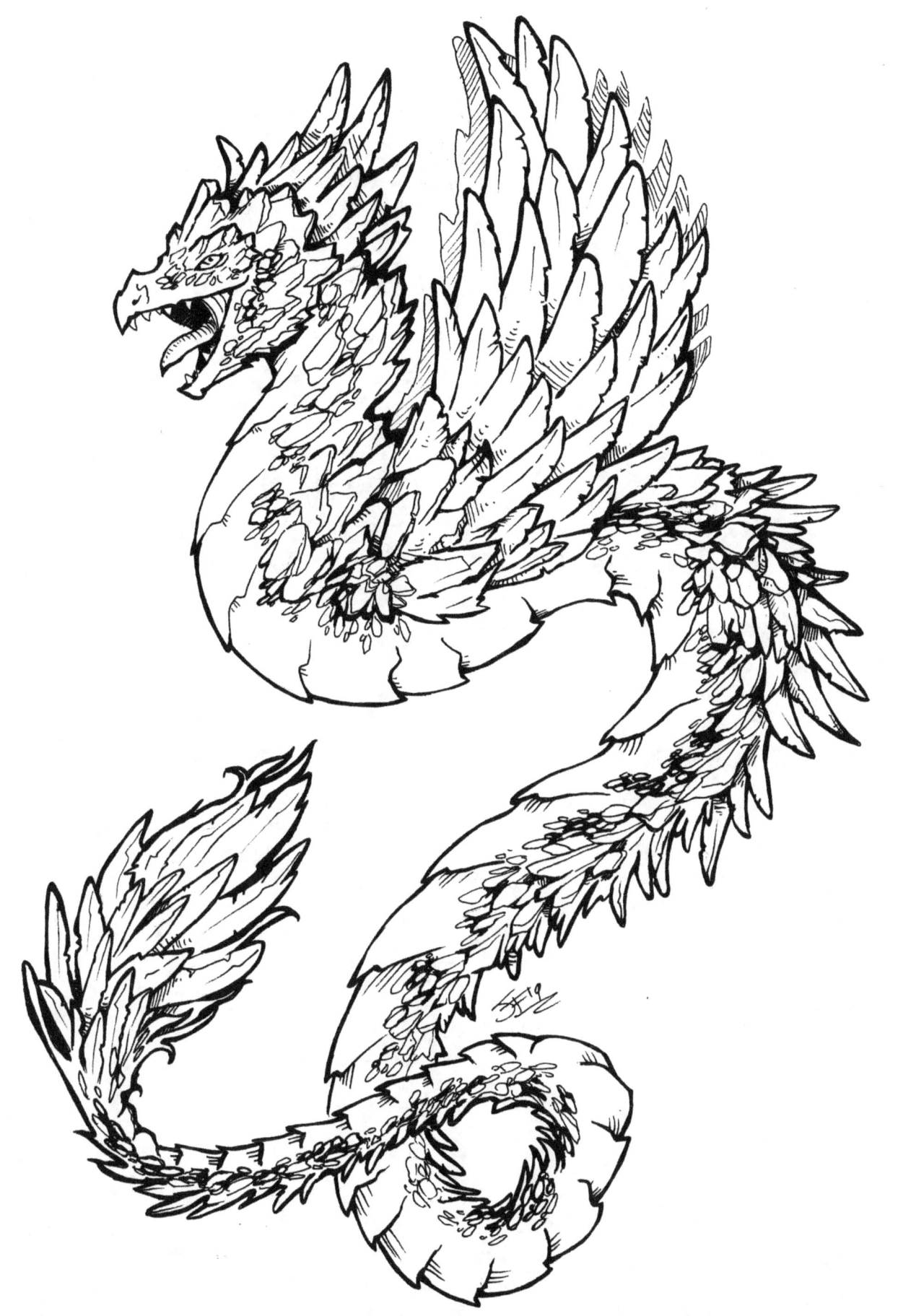

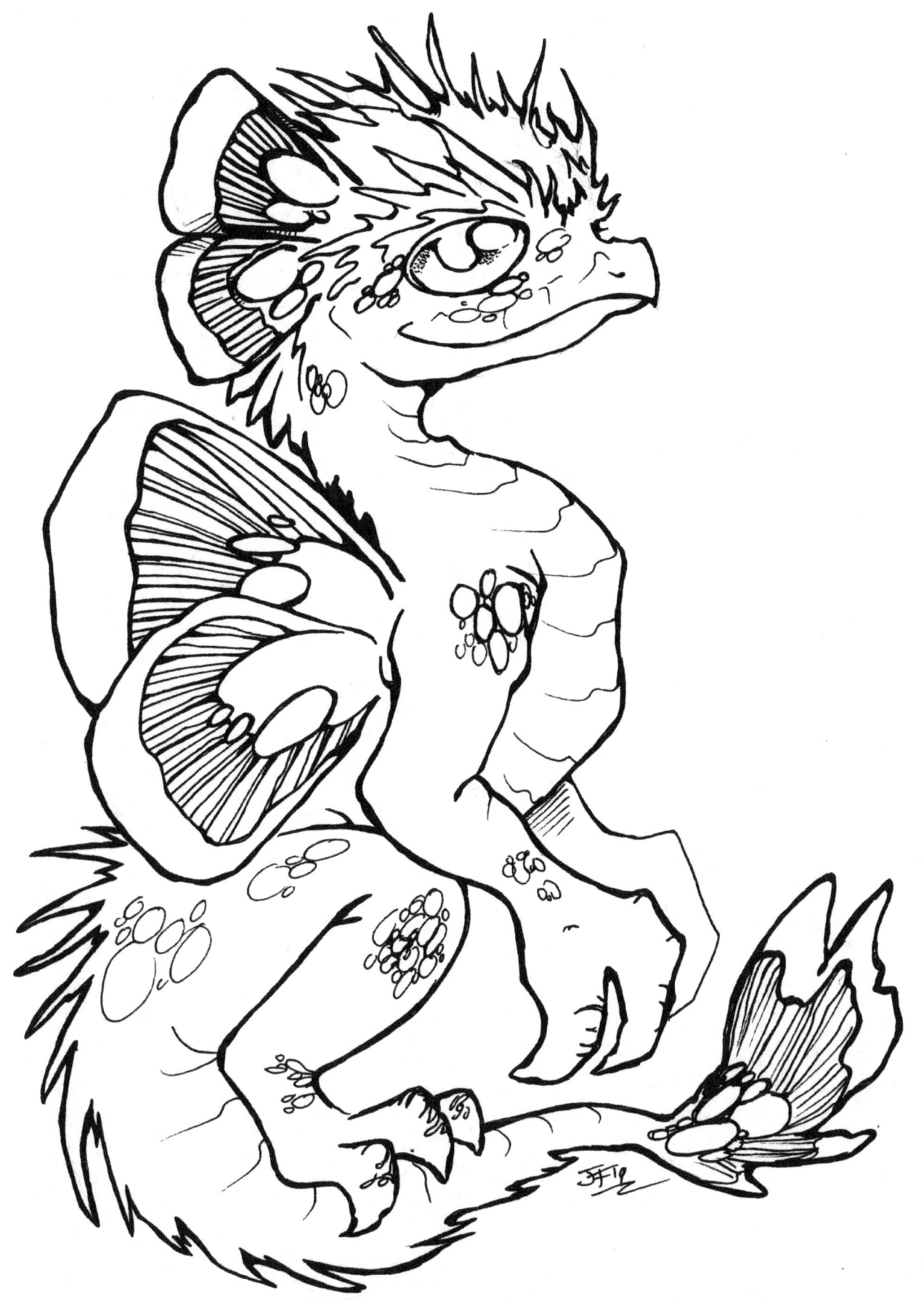

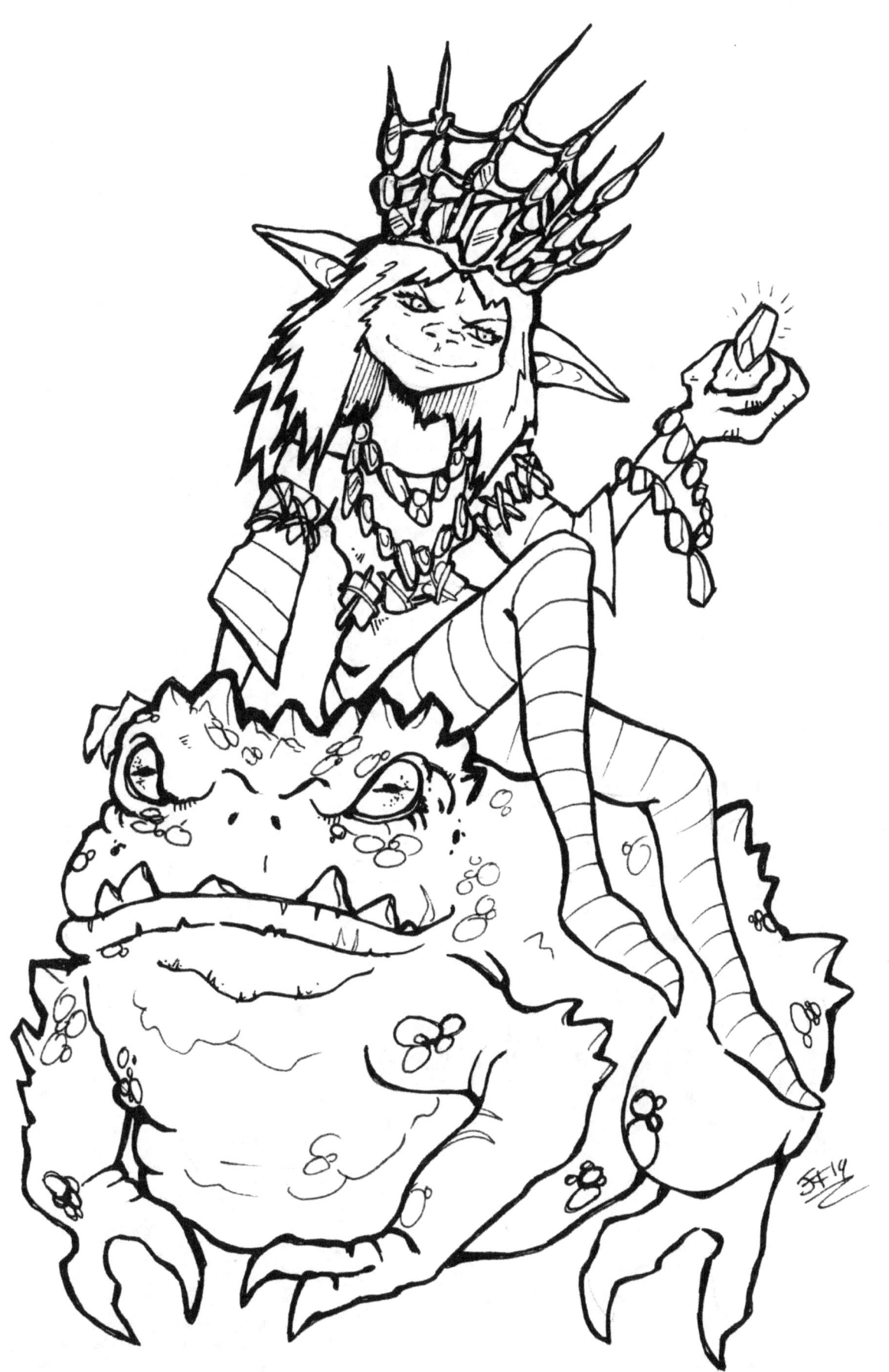

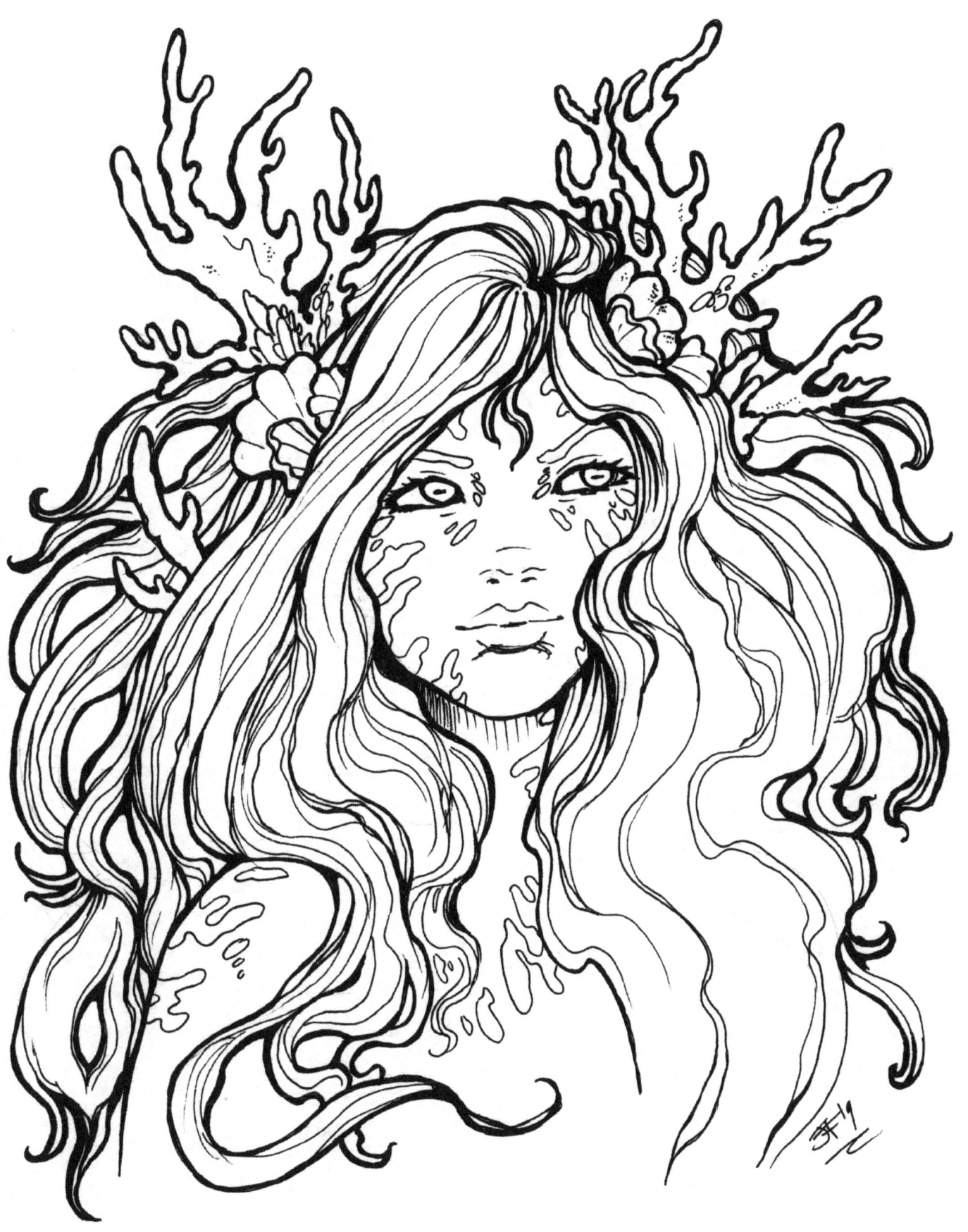

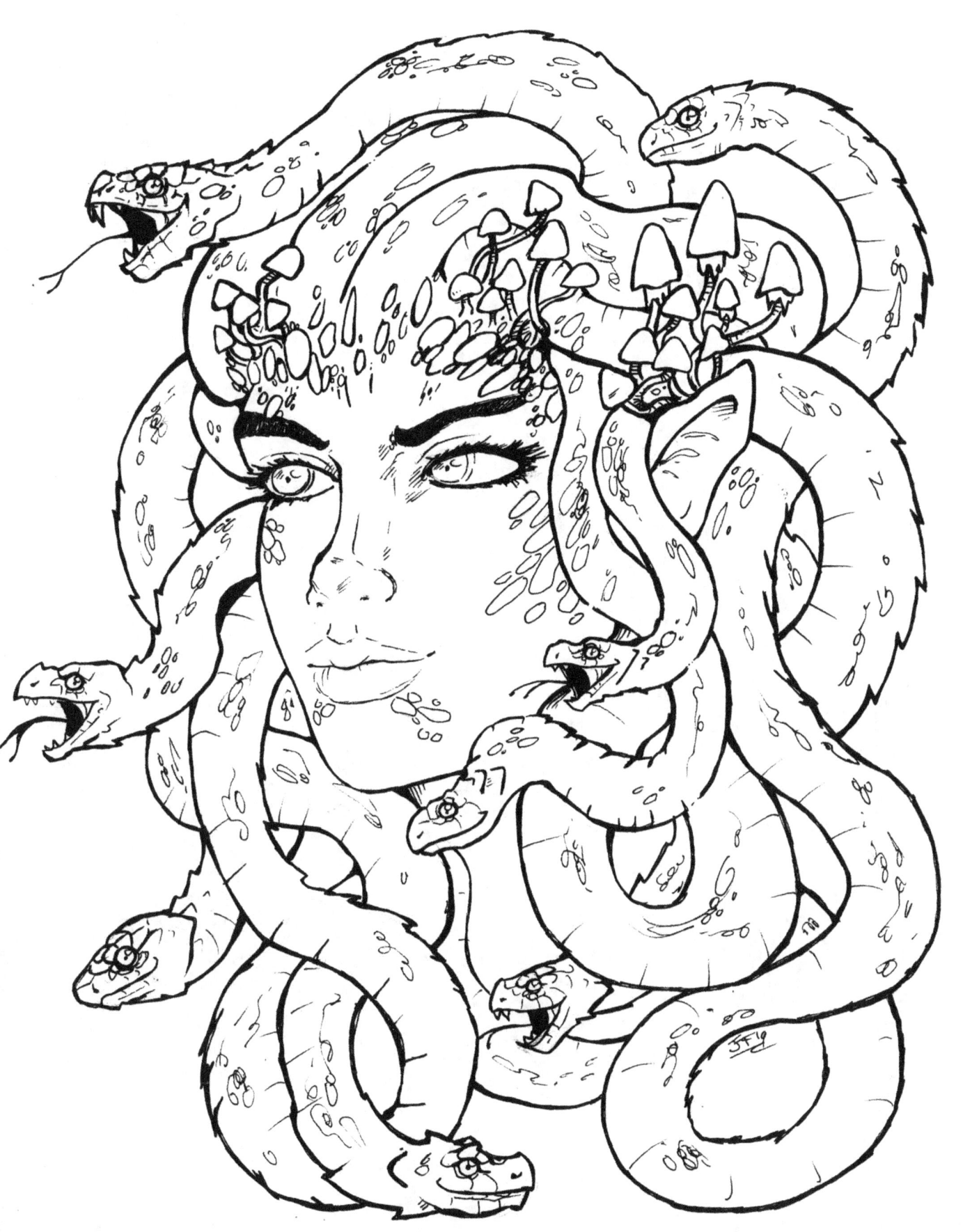

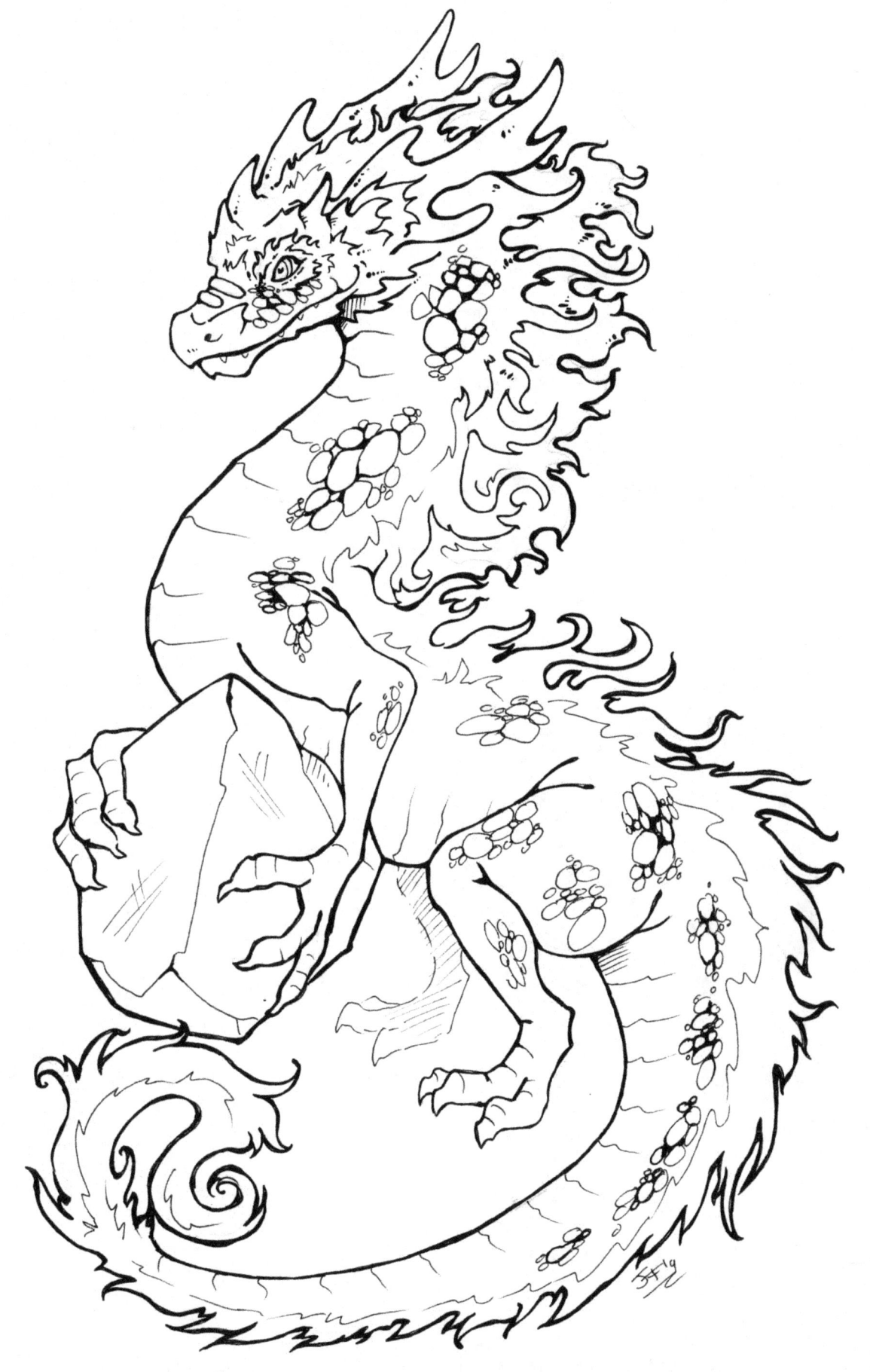

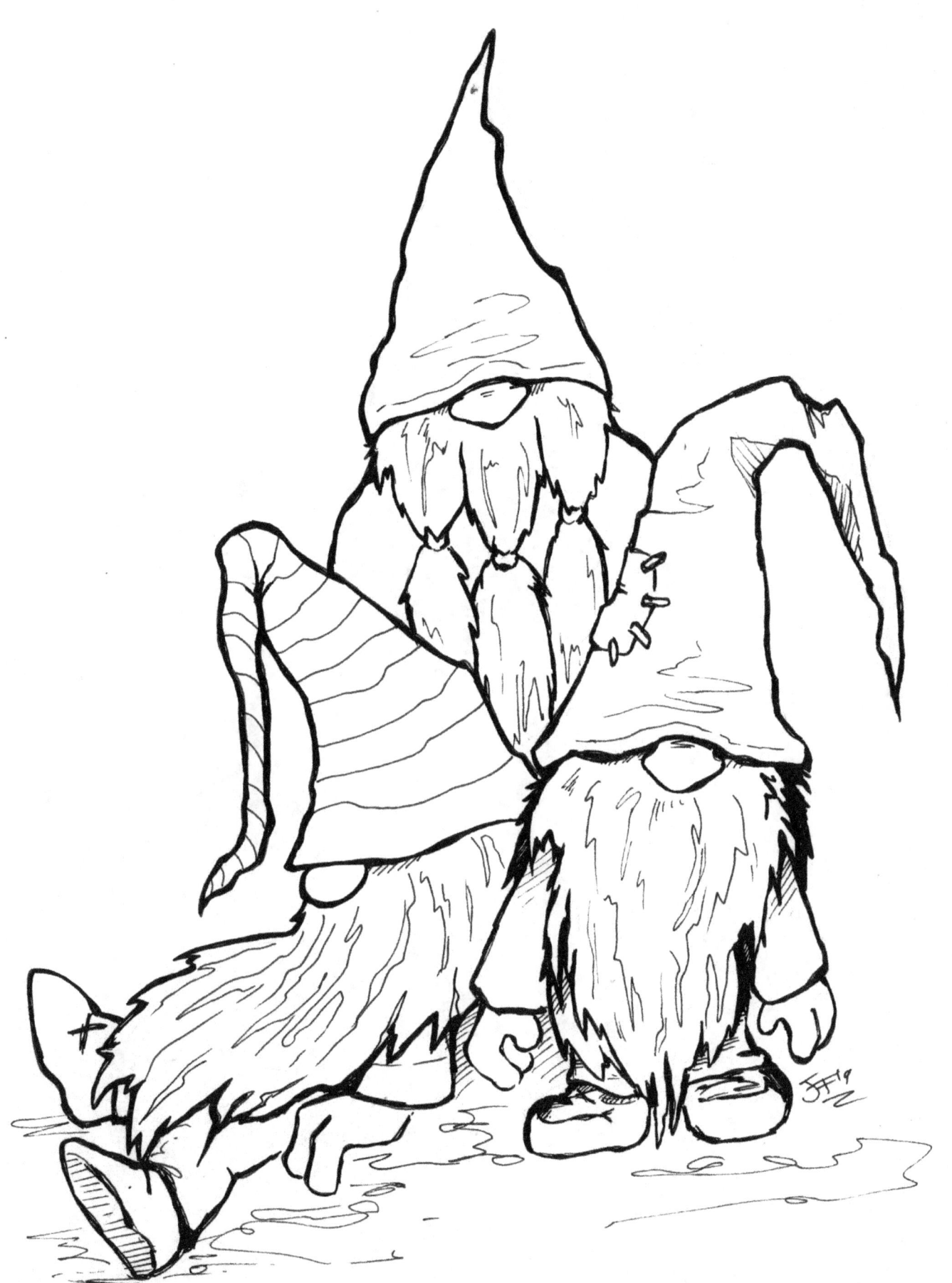

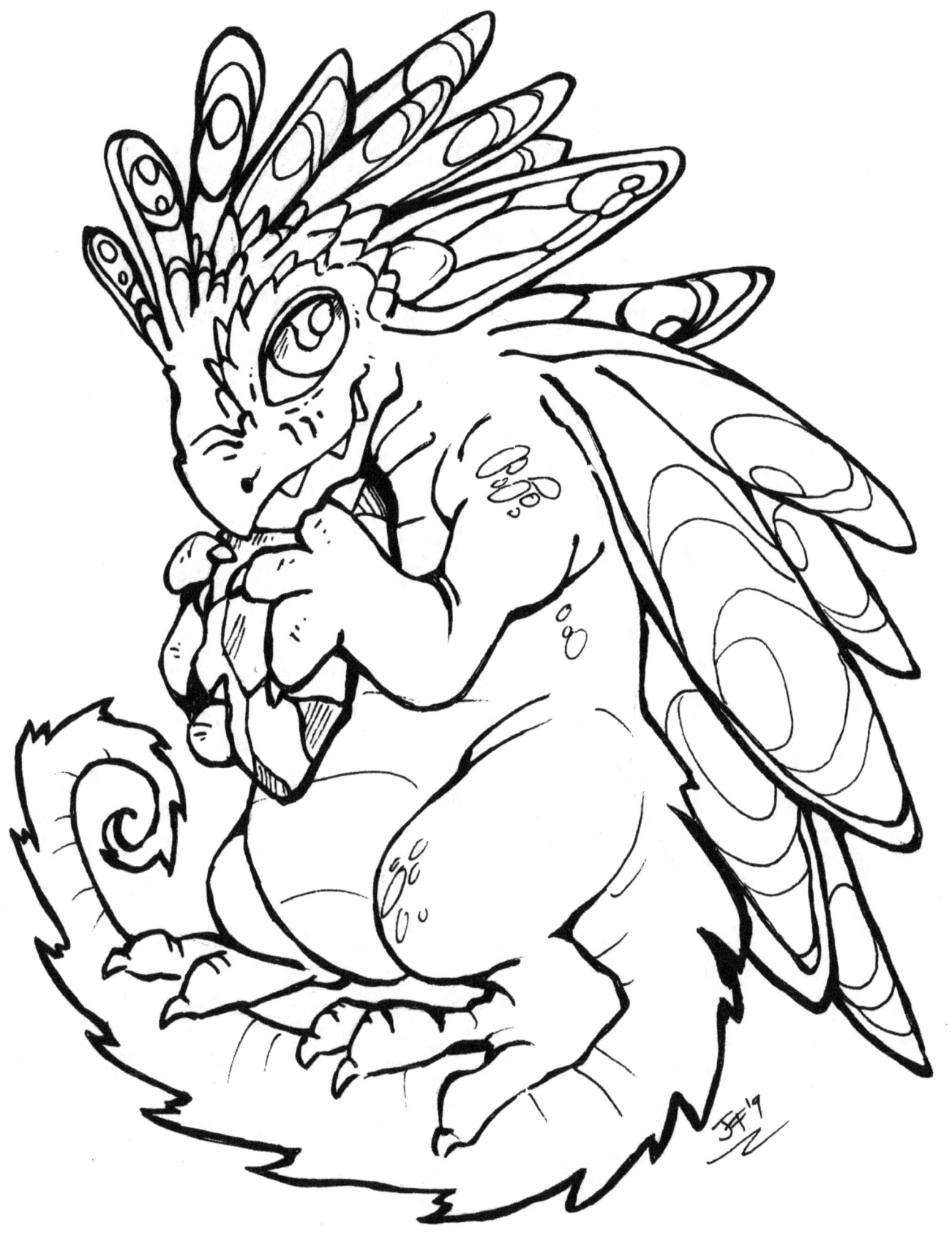

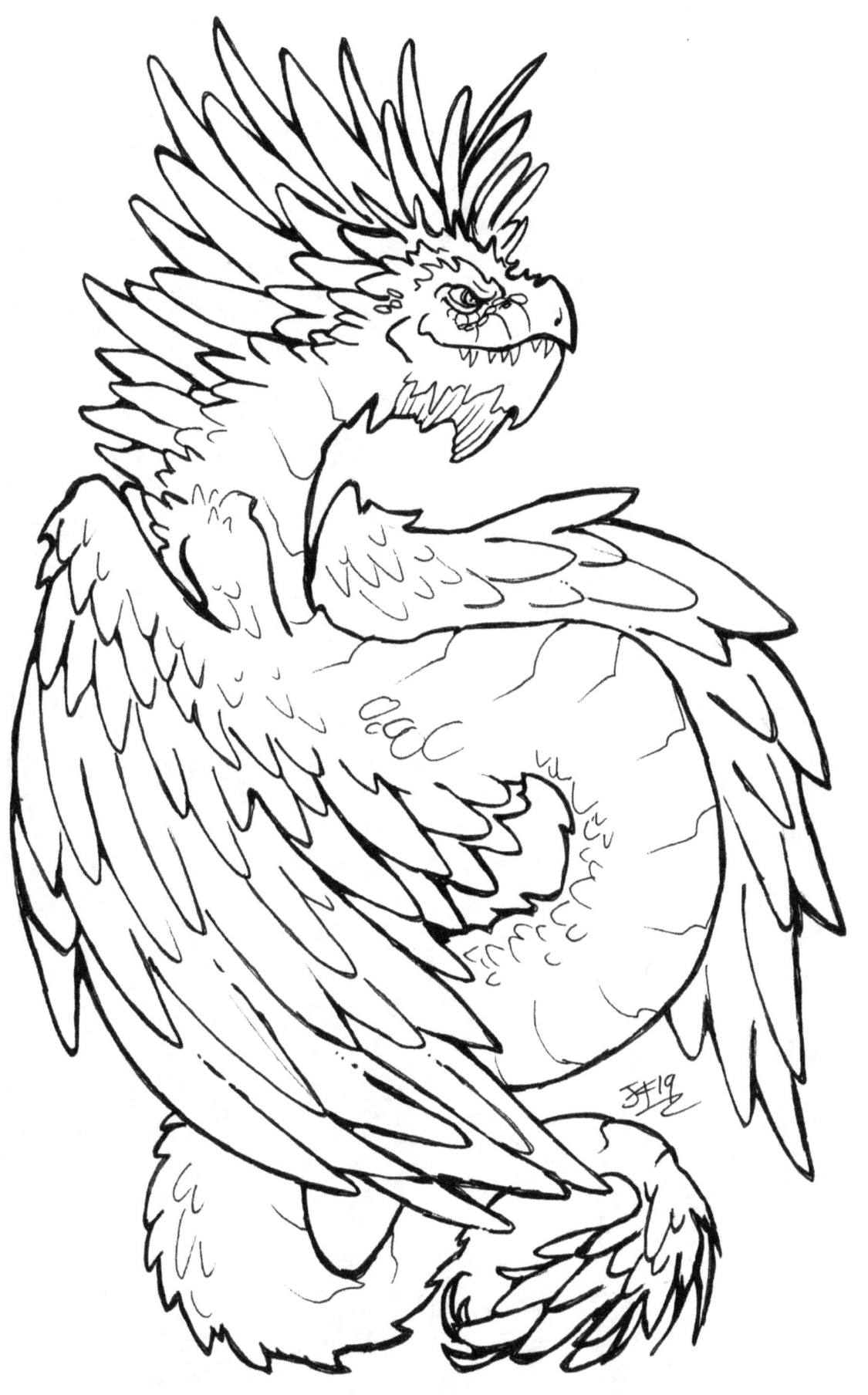

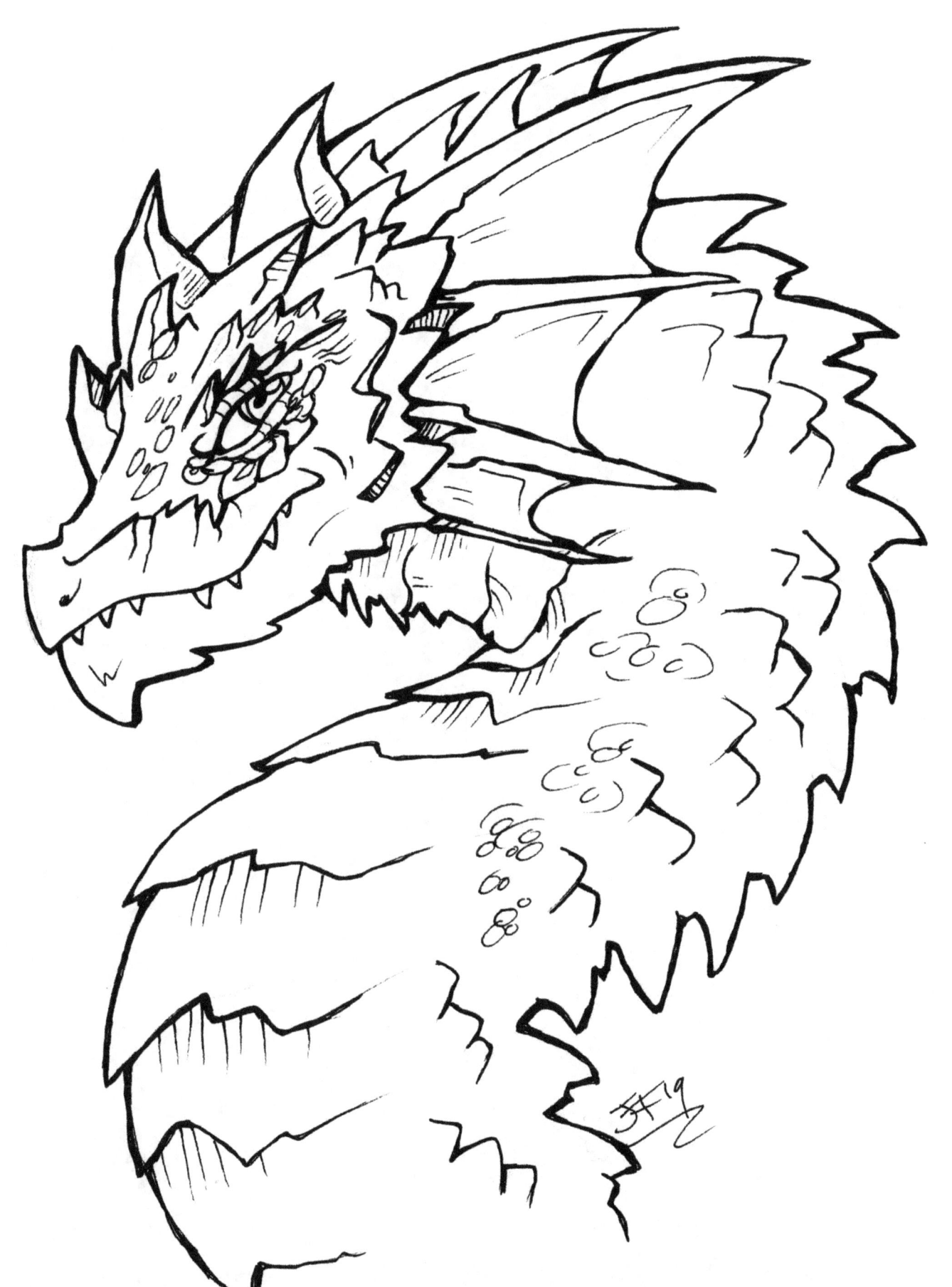

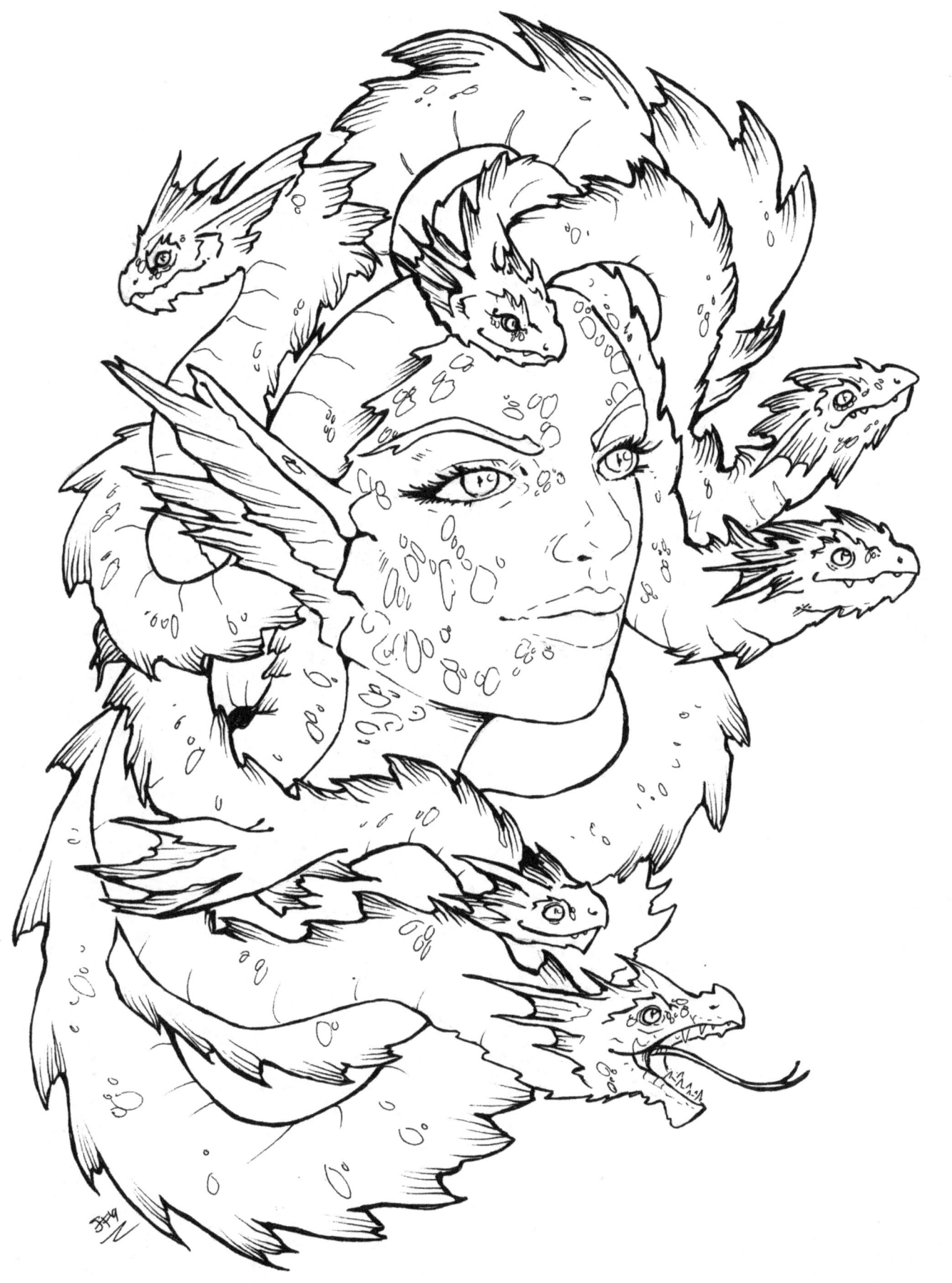

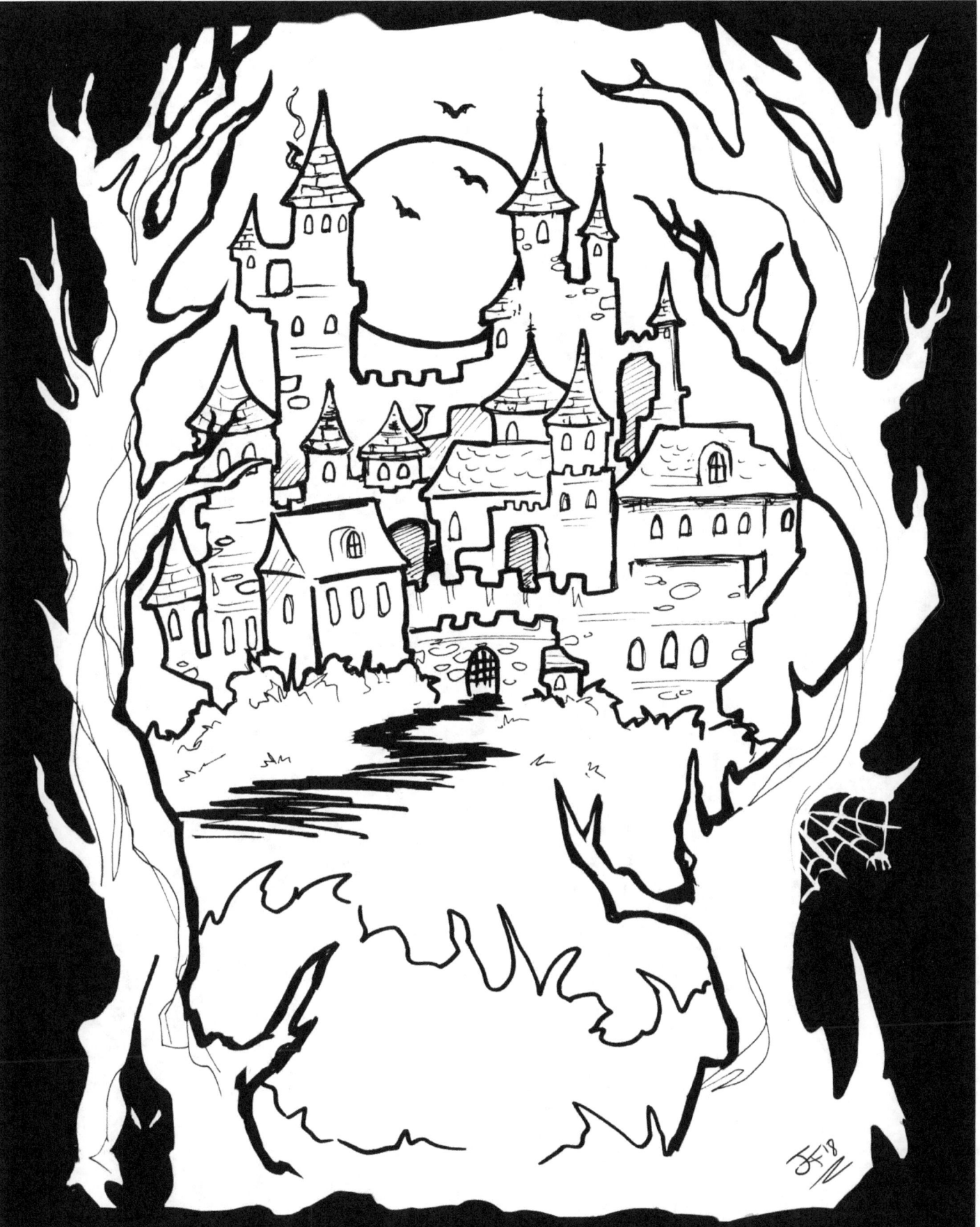

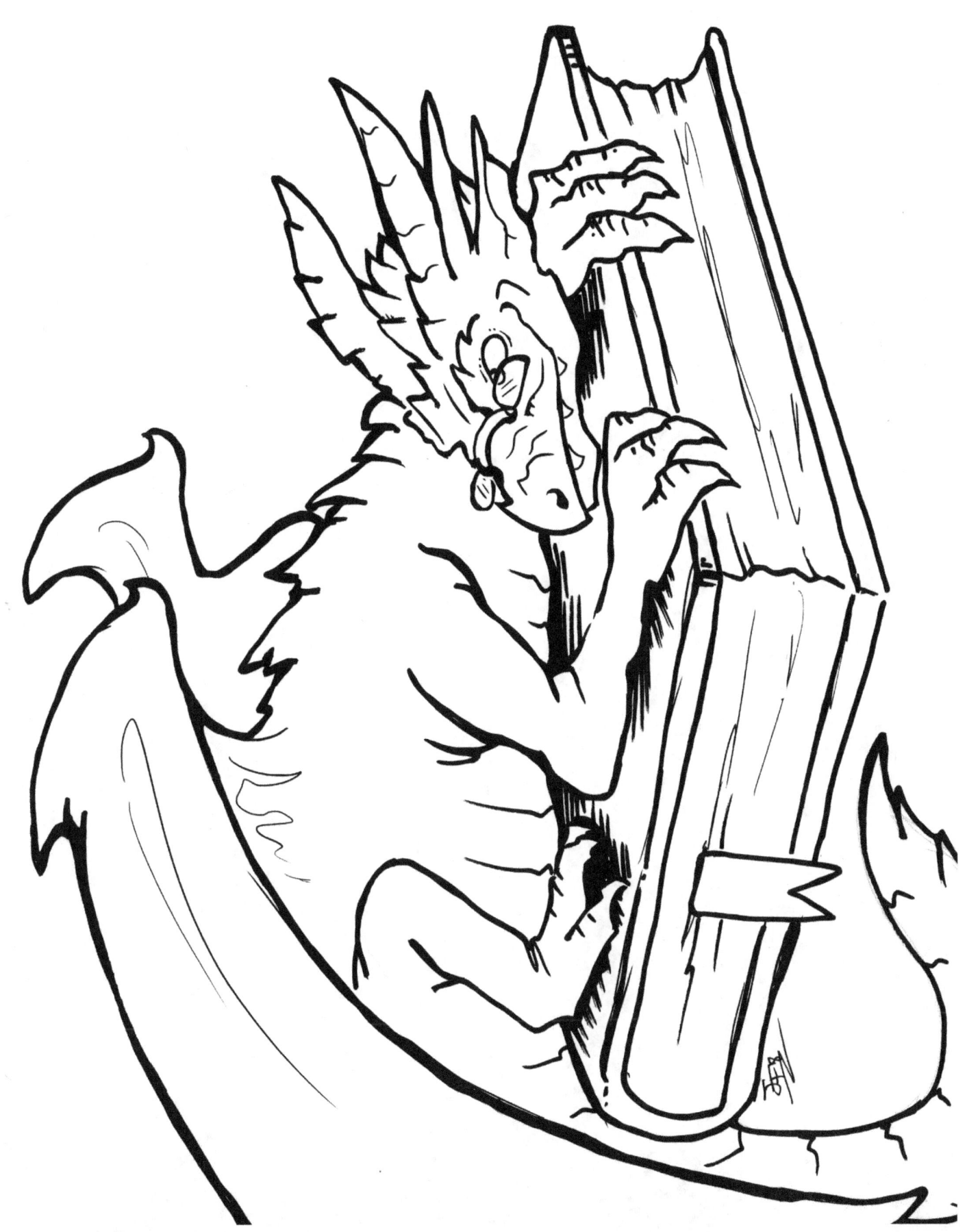

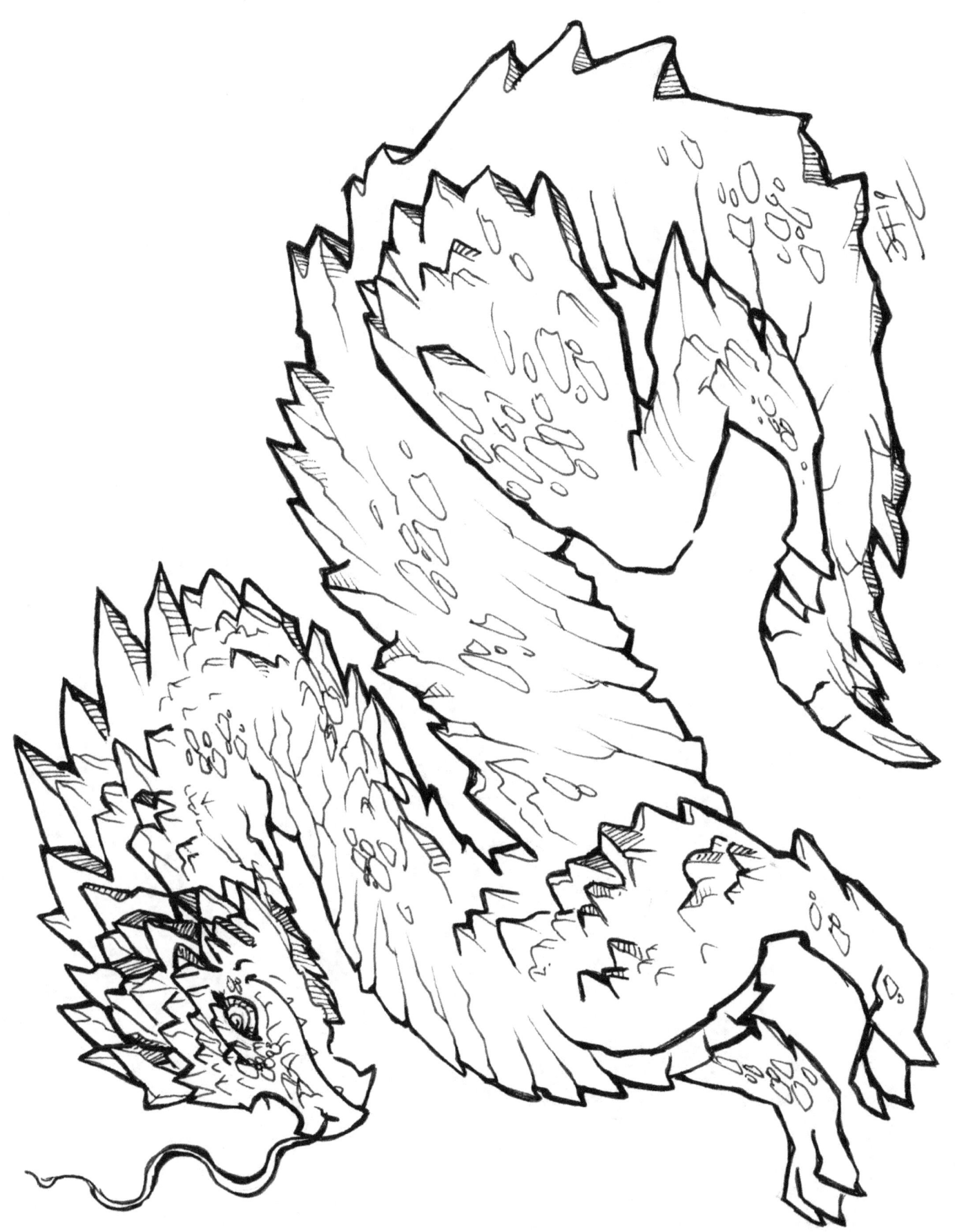

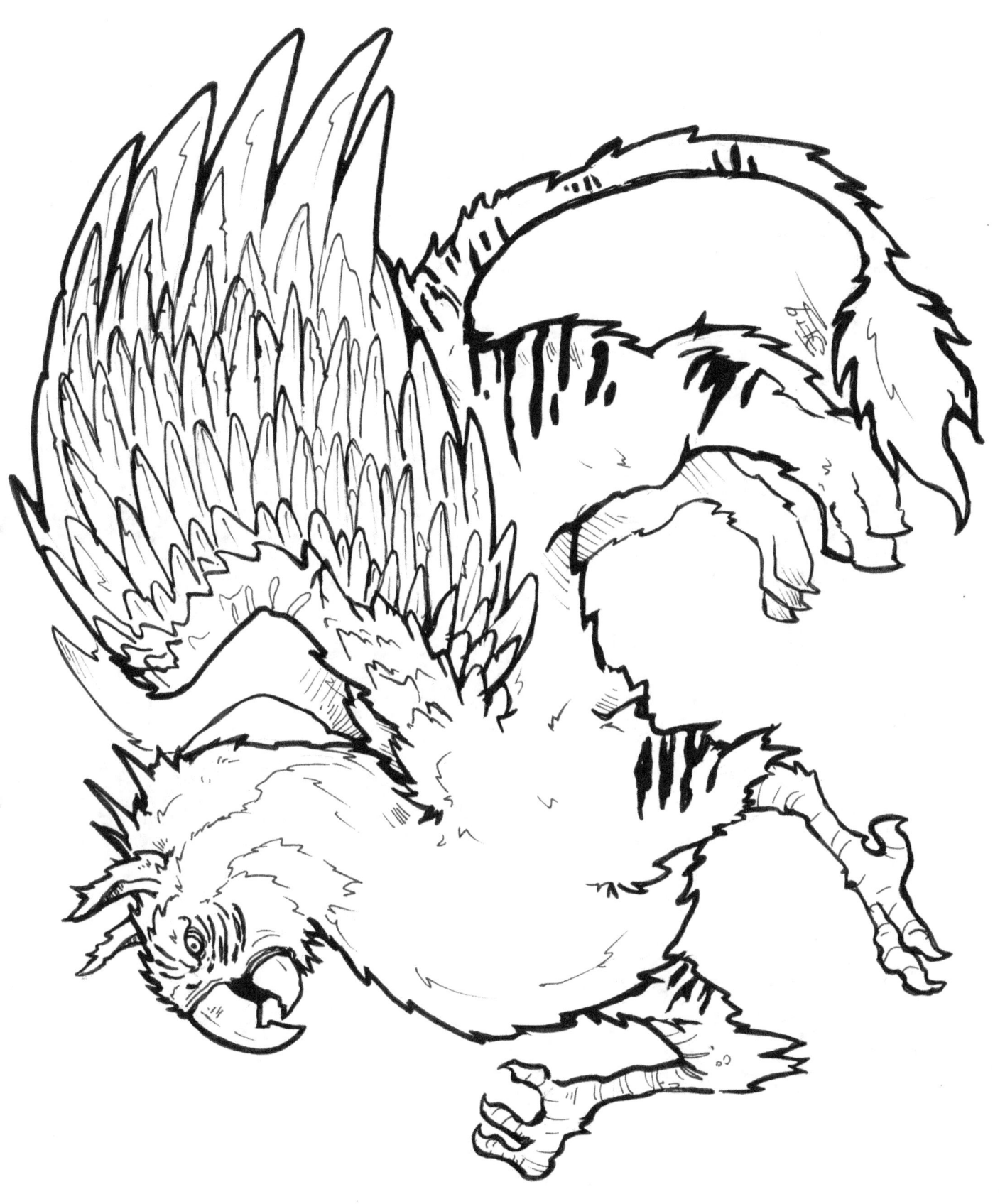

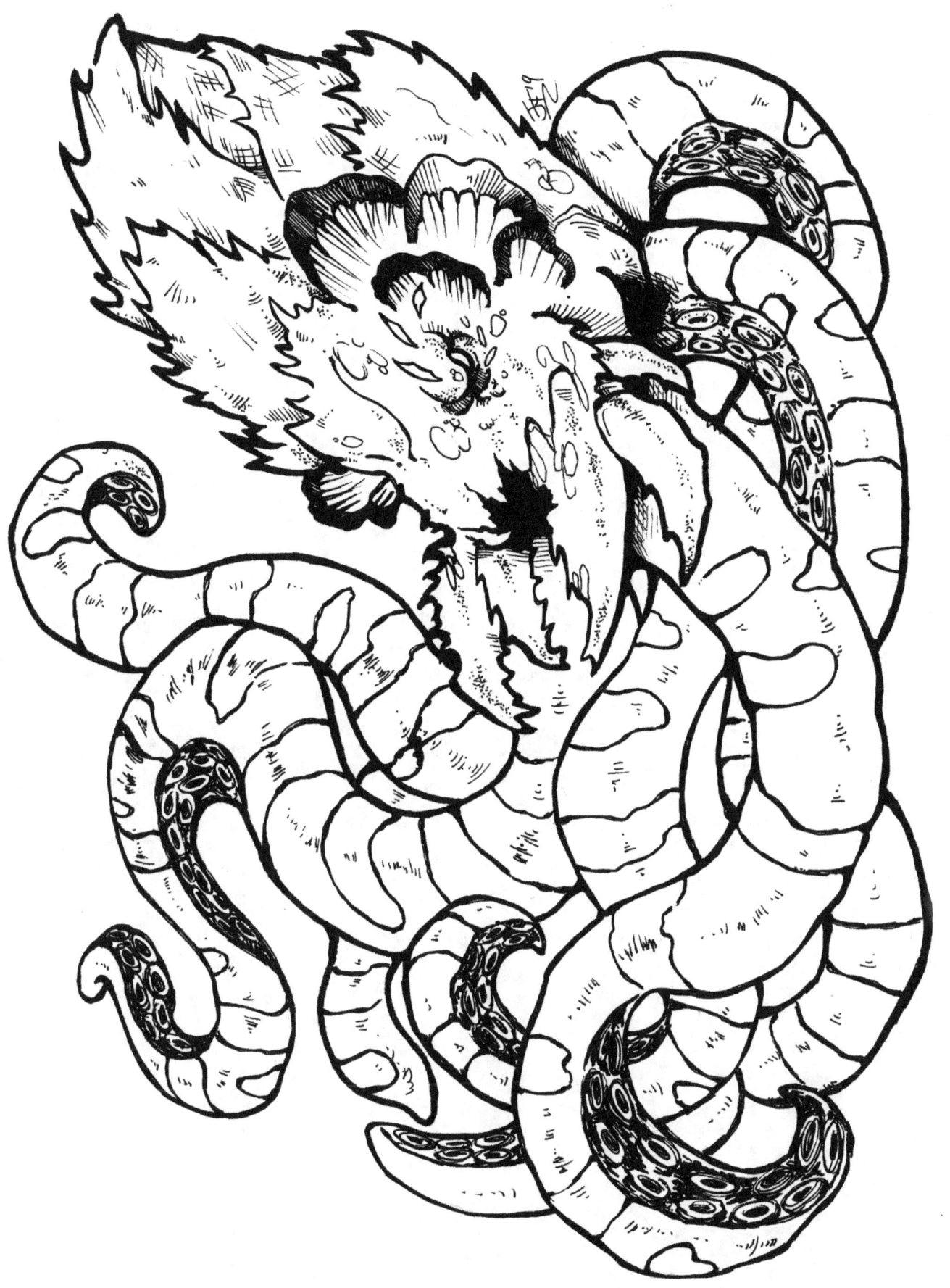

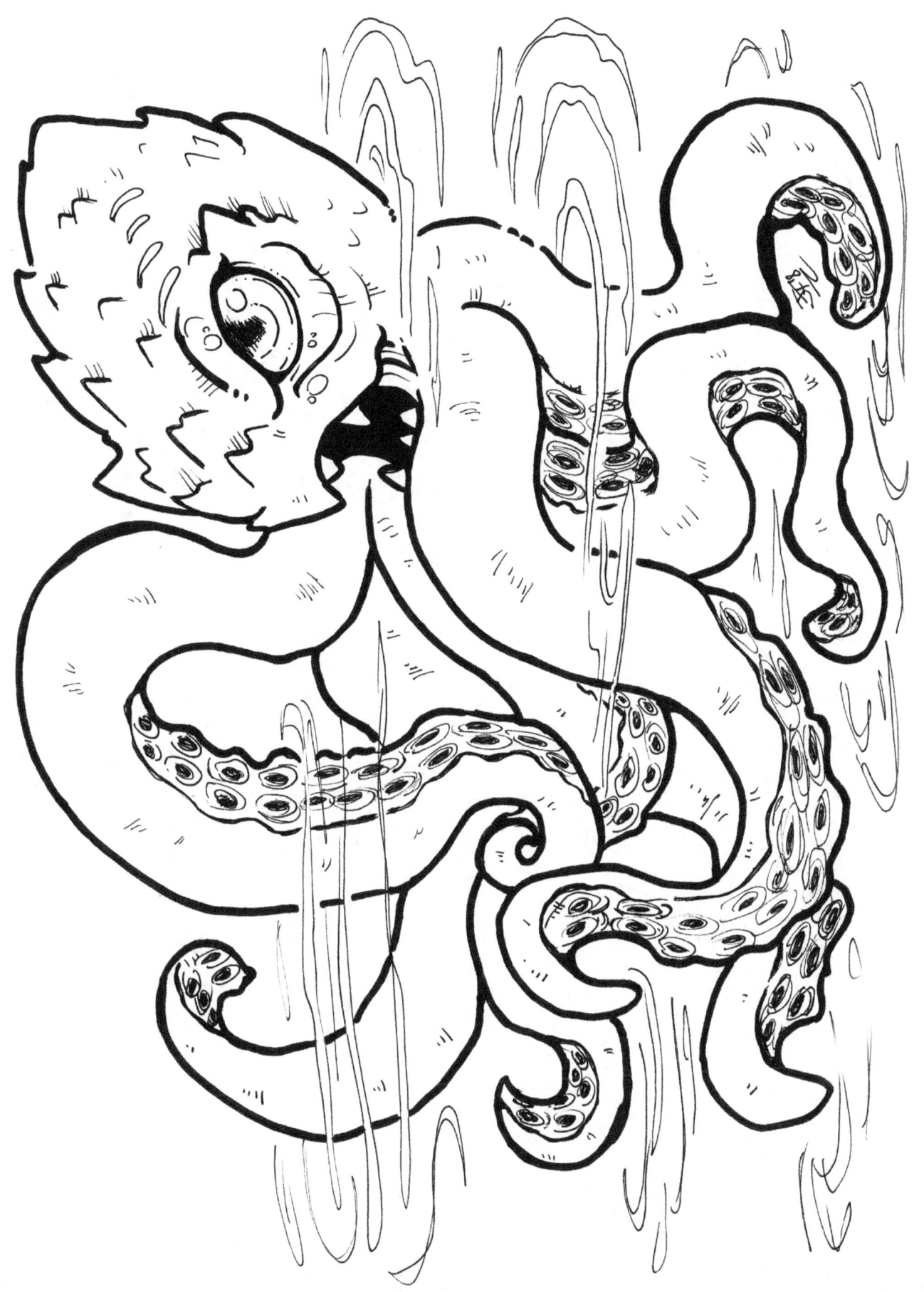

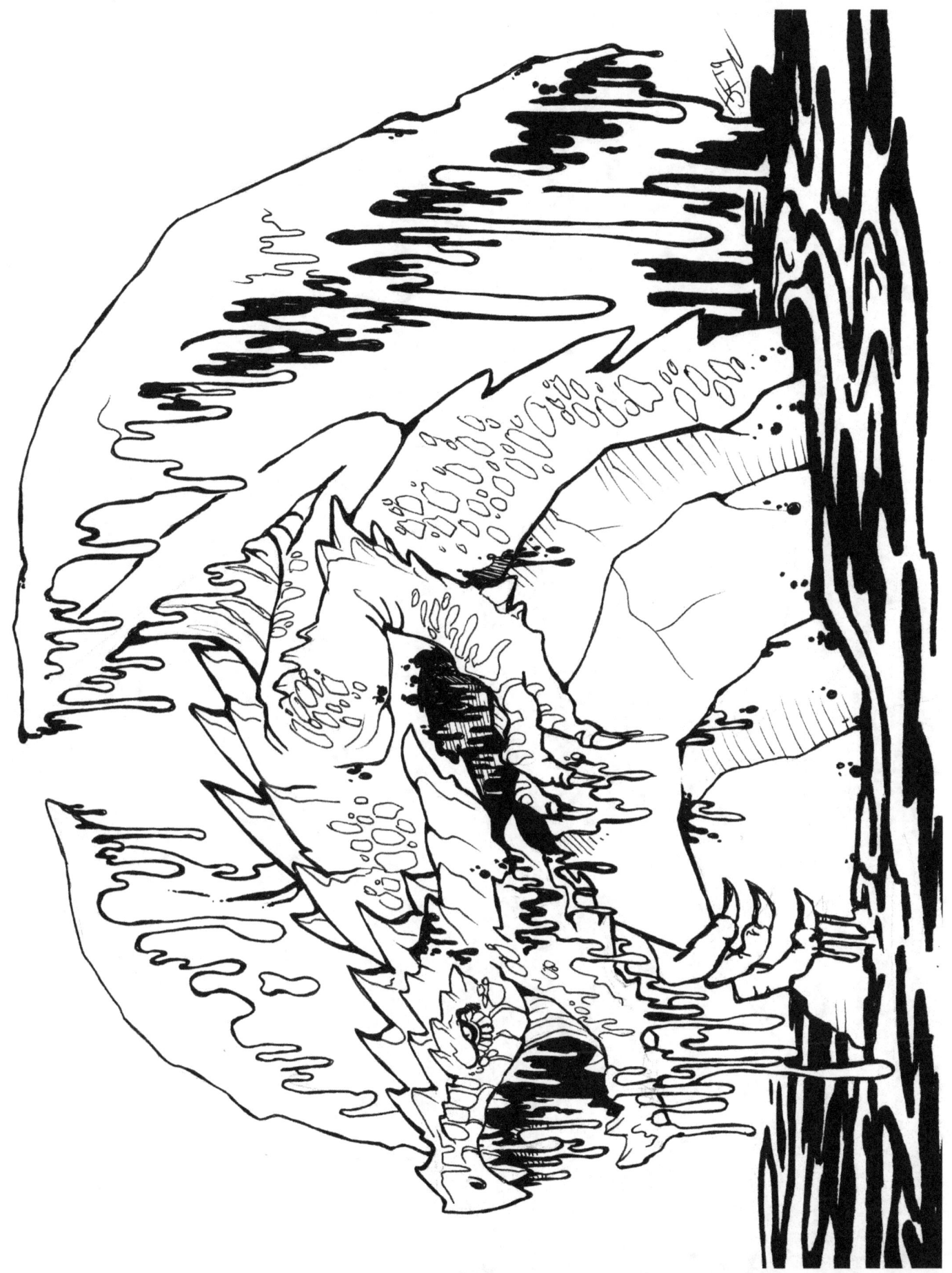

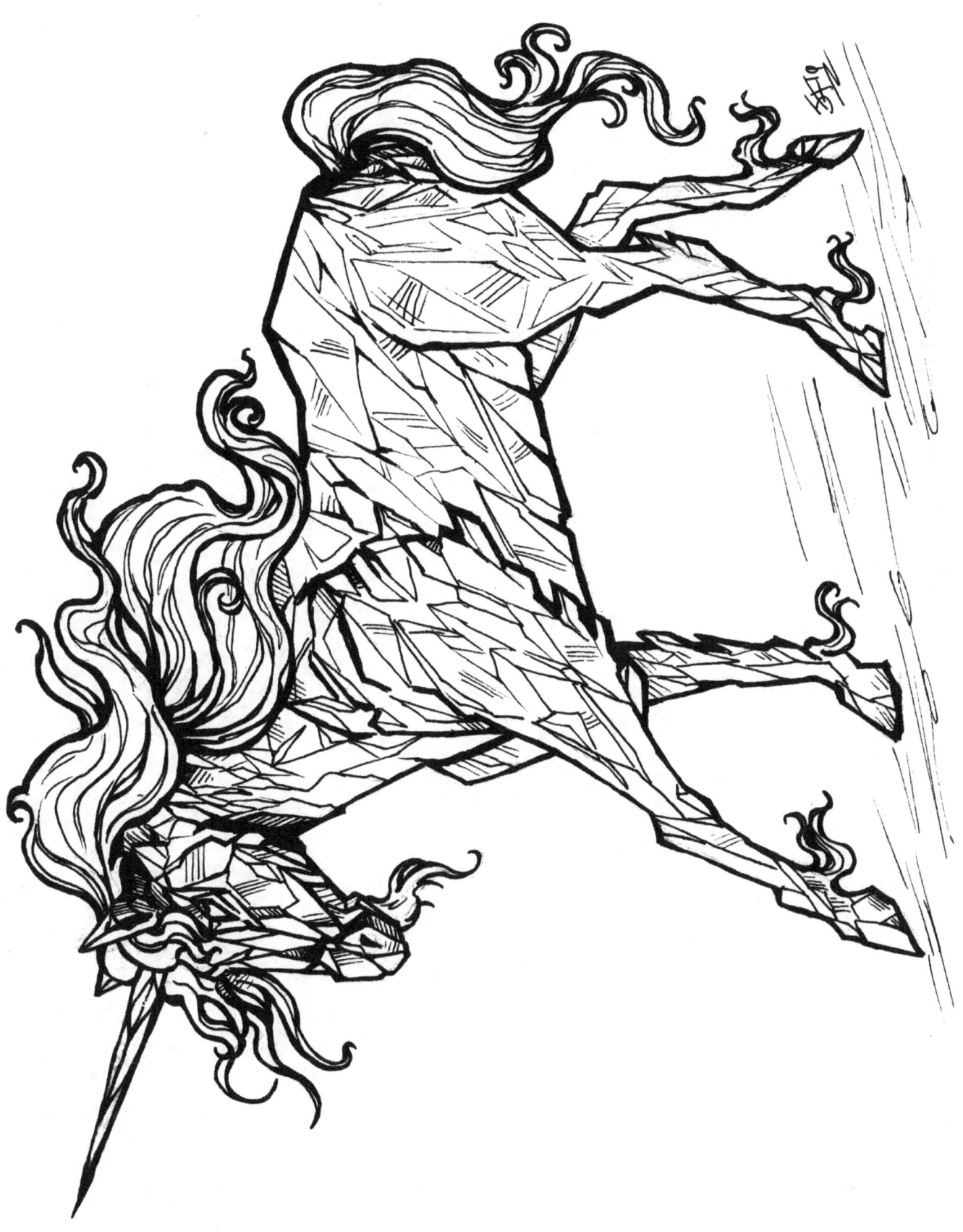

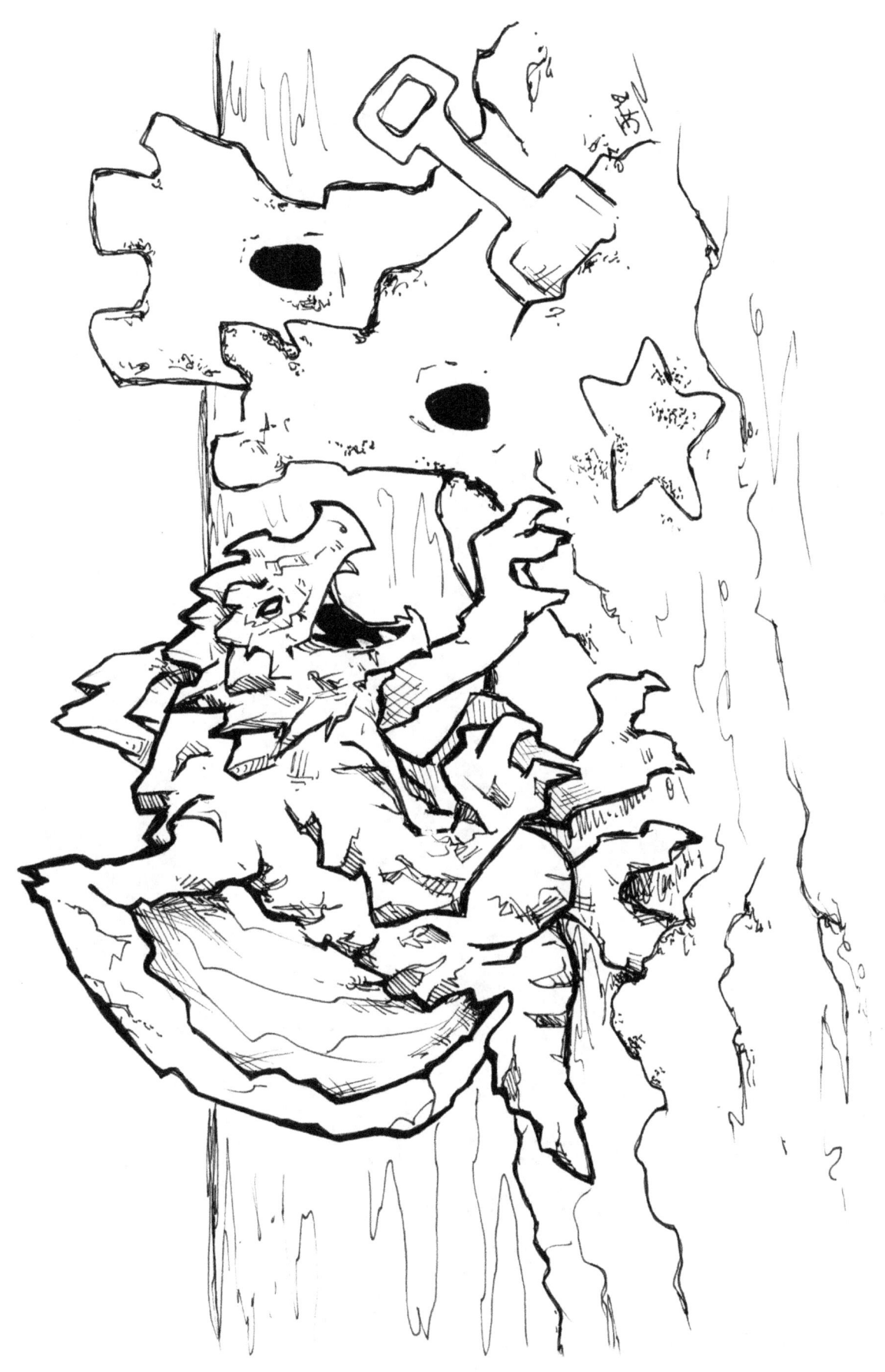

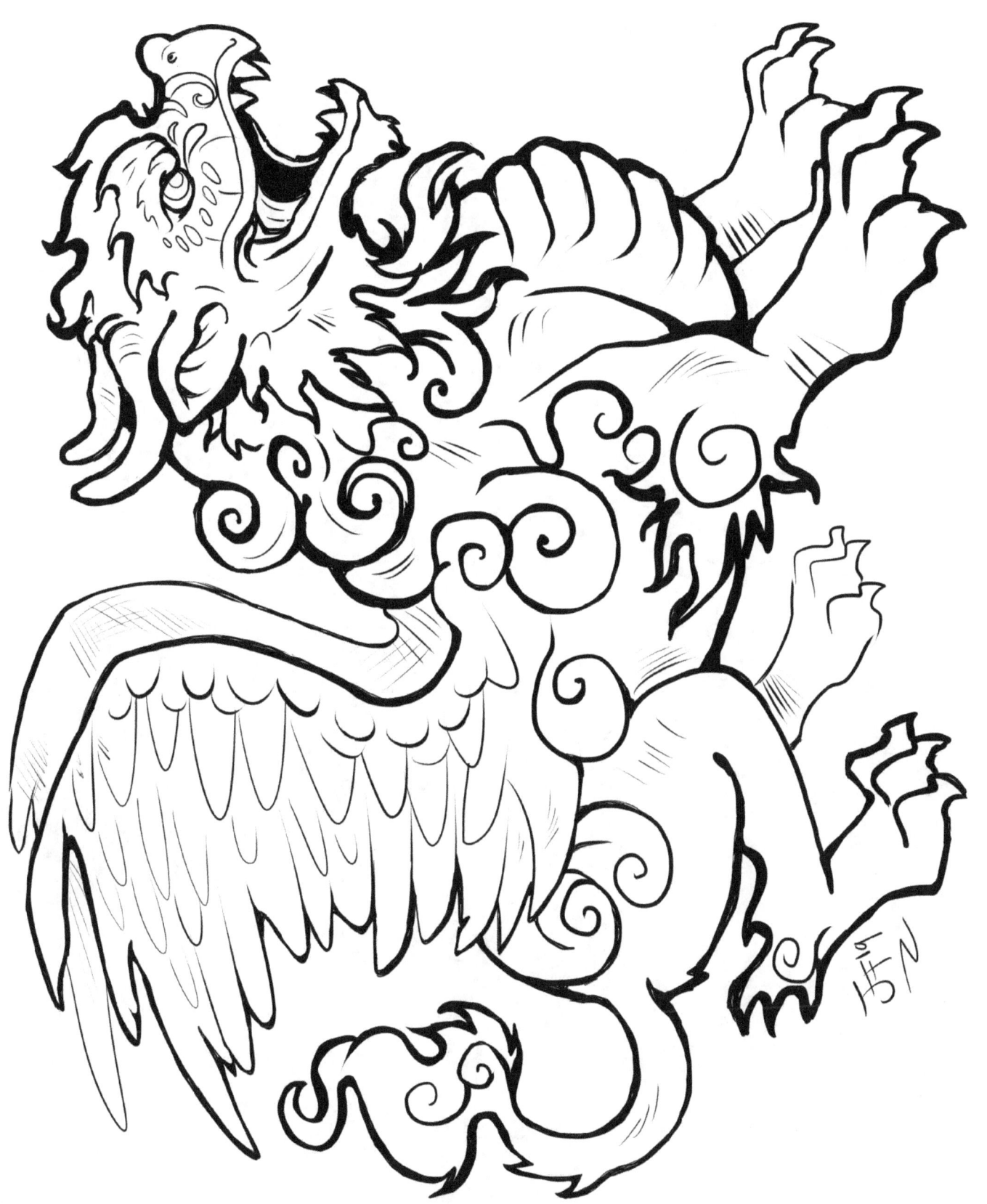

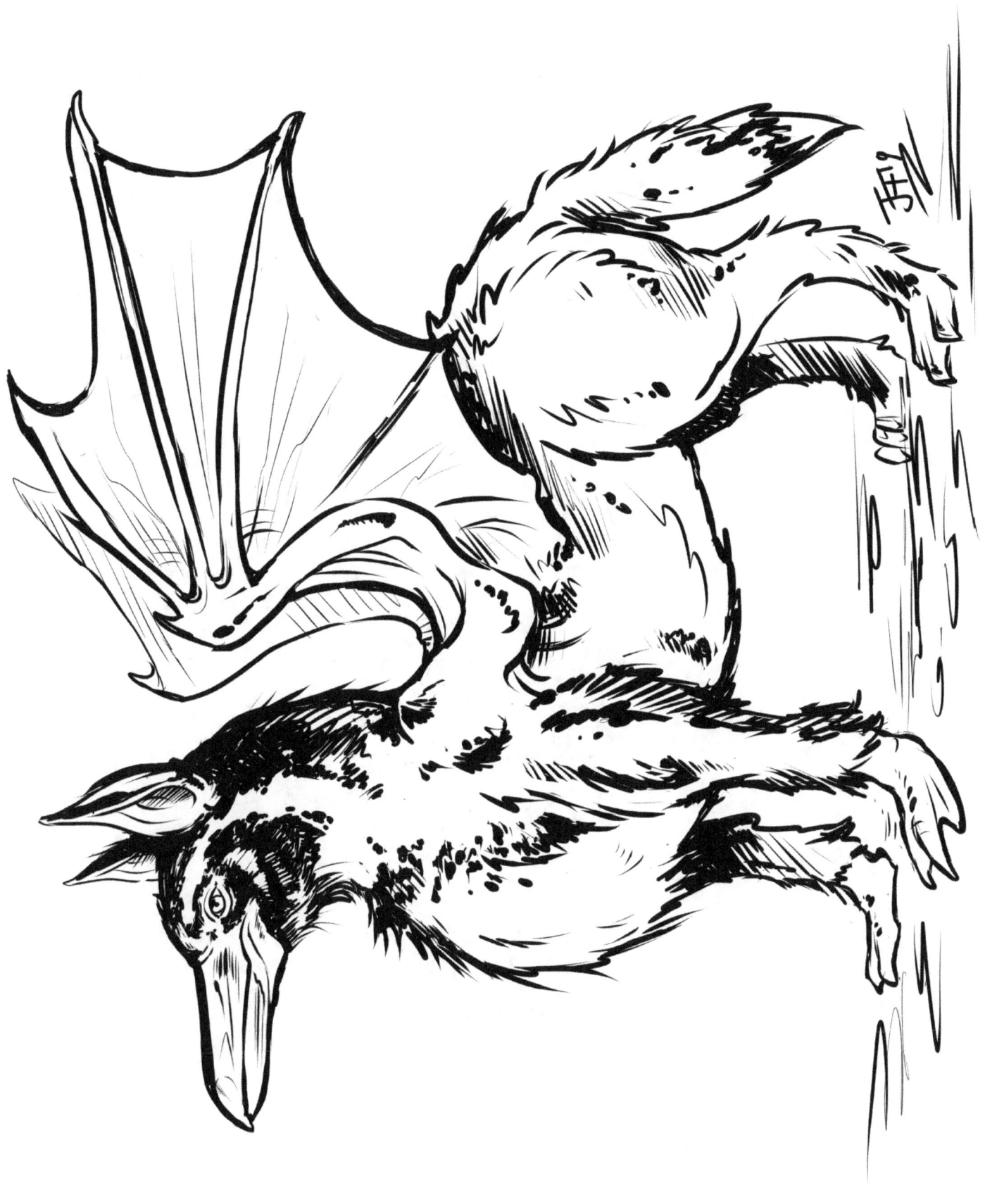

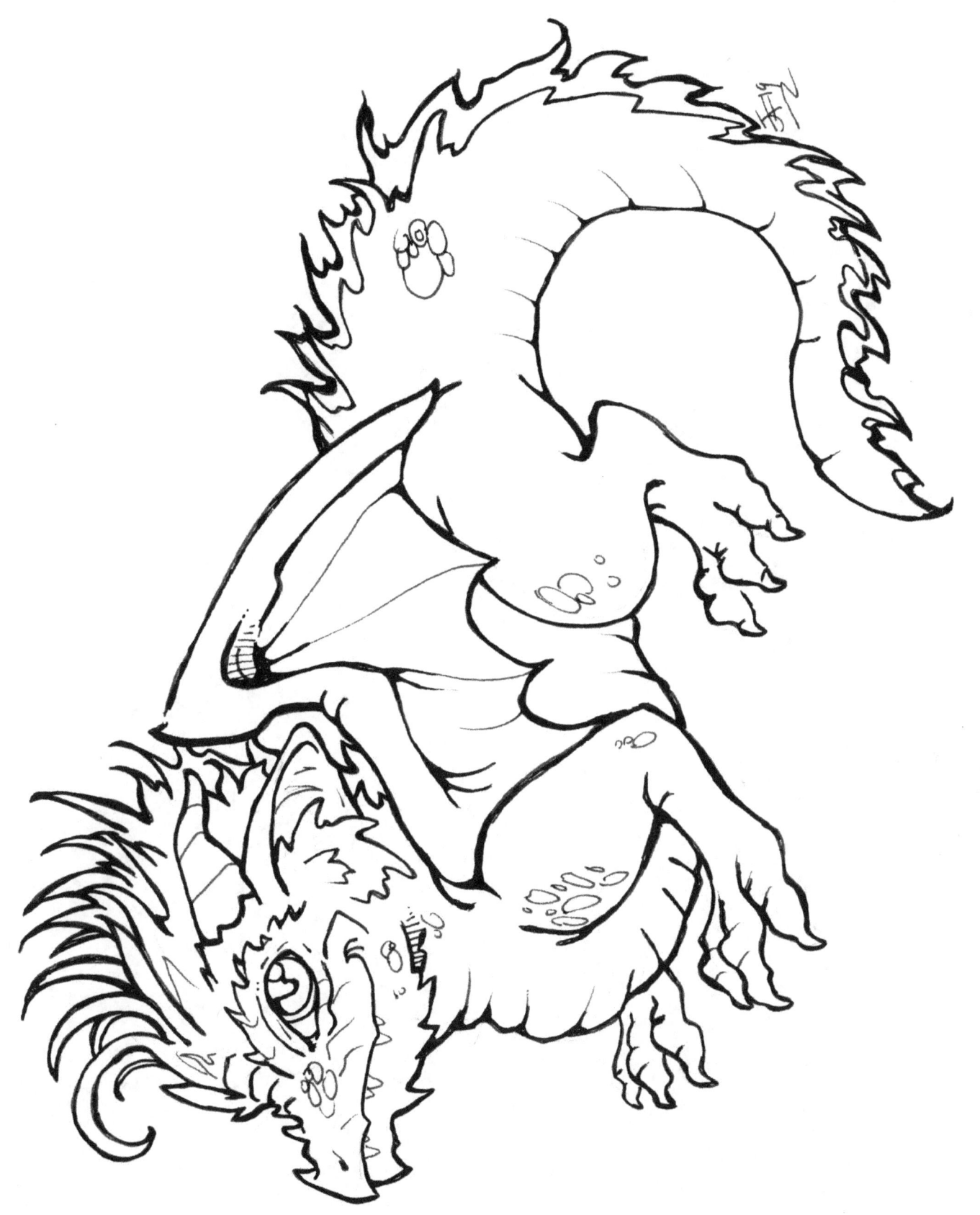

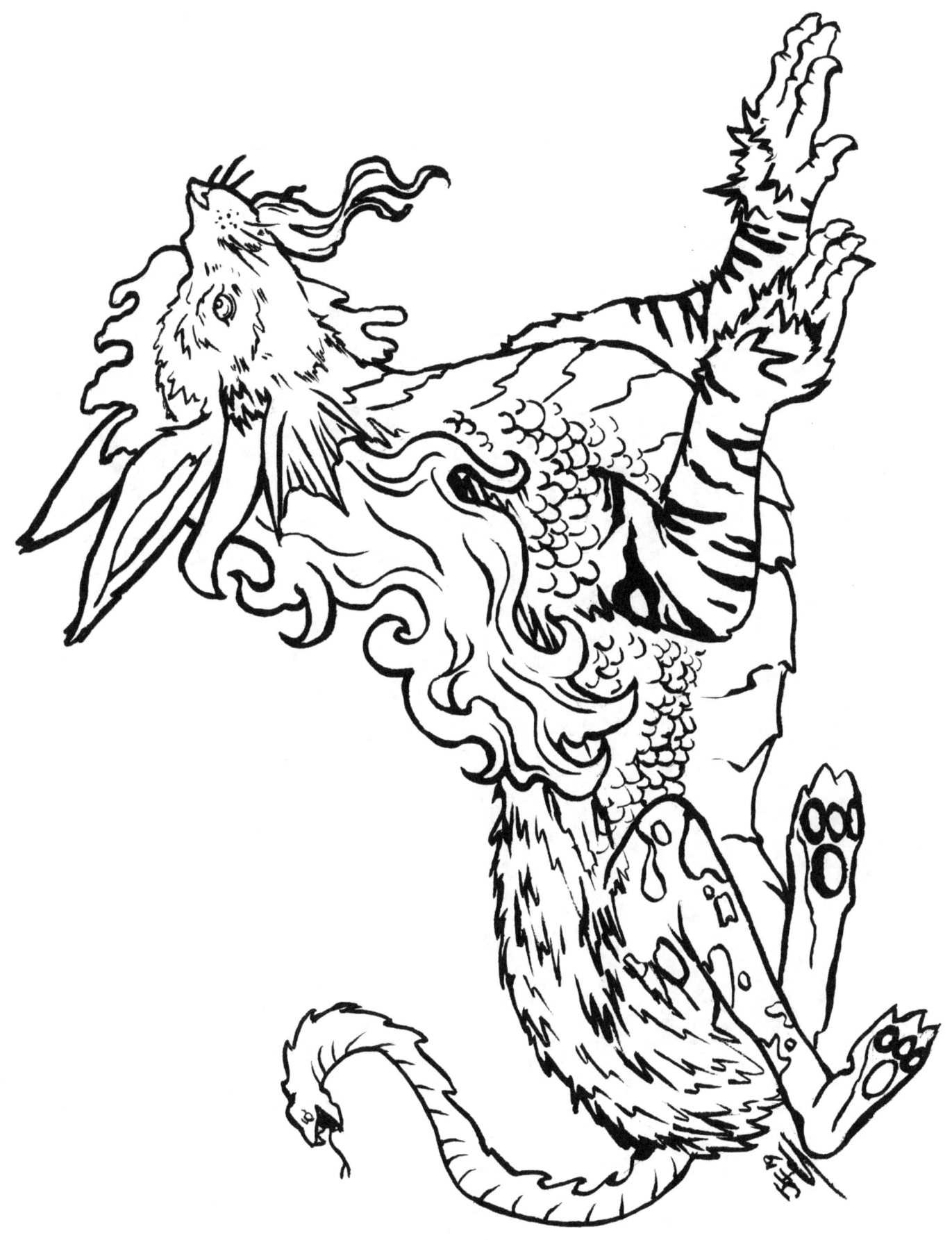

About the Artist

Jessica Cathryn Feinberg is a driven, quirky, creative gal who resides in Tucson, Arizona with a house full of books, cats, faeries, and other strange creatures.

Jessica has been fascinated by faeries and dragons since she was very young and has dedicated her life to writing, drawing, painting, and following in the footsteps of mysterious creatures. She is best known for her dragon, clockwork, and wildlife artwork as well as her field guides to rare creatures.

For more information please visit www.artlair.com

www.ingramcontent.com/pod-product-compliance
Lightning Source LLC
Chambersburg PA
CBHW081000170526
45158CB00010B/2858